CREATING COMPUTER ART

Using Dabbler

CREATING COMPUTER ART

Using Dabbler

By Dawn Erdos and Ann Aubrey

Illustrated by John Sledd

CHARLES RIVER MEDIA, INC.
Rockland, Massachusetts

ACKNOWLEDGEMENTS

There are many people without whom this book would never have been created. Many thanks to Ann Aubrey for helping to write this book in a timely, professional, and engaging manner; to John Sledd for contributing all of the wonderful illustrations in Section II of this book; Reuben Kantor of QEP Design for such professional and efficient production and editorial services; David Pallai, publisher of Charles River Media for his patience and support; Daryl Wise, Tad Shelby, and all of the fine folks at Fractal Design Corporation for creating yet another incredible product, thus making my work all the more pleasant; Margot Maley of Waterside Productions Literary Agency for her unfailing support and objectivity. Thank you all for your contributions and for your friendship.

Publisher: David F. Pallai
Printer: InterCity Press, Rockland, MA.

CHARLES RIVER MEDIA, INC.
P.O. Box 417
403 VFW Drive
Rockland, Massachusetts 02370
617-871-4184
617-871-4376 (FAX)
chrivmedia@aol.com

This book is printed on acid-free paper.

All brand names and product names mentioned in this book are trademarks or service marks of their respective companies. Any omission or misuse (of any kind) of service marks or trademarks should not be regarded as intent to infringe on the property of others. The publisher recognizes and respects all marks used by companies, manufacturers, and developers as a means to distinguish their products.

Dabbler is a registered trademark of Fractal Design Corporation. Macintosh is a registered trademark of Apple Corporation. Windows is a registered trademark of Microsoft Corporation.

CREATING COMPUTER ART
Using Dabbler
By Dawn Erdos and Ann Aubrey
Illustrated by John Sledd First Edition—1996
ISBN 1-886801-03-7
Printed in the United States of America

96 97 98 99 00 6 5 4 3 2 1

CHARLES RIVER MEDIA titles are available for site license or bulk purchase by institutions, user groups, corporations, etc. For additional information, please contact the Special Sales Department at 617-871-4184.

CONTENTS

INTRODUCTION

WHAT IS COMPUTER ART?

What do we mean by computer art? You do well to ask. When you hear the words "computer art," you can be certain of one thing: It's like hearing the word "beauty." The word itself isn't explicit. What's beautiful to one individual might be plain or hideous to another (remember that great *Twilight Zone* episode where

IN THIS CHAPTER

- What is computer art?
- Computer art tools
- A basic art lesson

"beauty" meant having a jutting forehead, a twisted mouth, and deepset blackened eyes?). As that show illustrated, "beauty" is a purely subjective value. So it is with "computer art." Each person has an individual understanding of what computer art is and how it is created.

Ten years ago, the definition of computer art might have involved advanced paint and drawing tools and the ability to manipulate images on a two-dimensional surface. Nowadays, that definition includes animated simulation of three dimensions, and the creation of special effects unlike any available before in the history of drawing and movies. Talk about subjective!

When you use the words "computer art" it is prudent to be more specific. So, what do we mean when we refer to creating computer art with Dabbler? We're talking basics here, folks, basic painting and drawing. That is not to demean the program. Not at all. It is an excellent program, for its intended purpose.

Dabbler is designed as an introduction to art, as a way to step into the realm of electronic art and get your feet wet with little risk. You can test your talents and begin to stretch those nascent skills without being overwhelmed with thousands of available functions and options, as you might be with more advanced products.

Yes, there are other beginning art products on the market, but not all programs tutor you through your feeble first efforts at art. Dabbler includes a personal art tutor, which will teach you at your own speed and never lose its sense of humor.

COMPUTER ART TOOLS

With computer art programs, you'll be able to work with all of the traditional art tools you're used to, as well as many new digital features.

In addition to pen, pencil, spray paint can, paint brush, and several other basic drawing and painting tools, many applications even let you have access to special effects tools, including low-level animation.

Computer drawing and painting tools emulate their traditional counterparts. You can color with chalk the way you do in "real life" and achieve the same texture effects as if you were coloring on textured paper. You can draw with pen or marker, and never have to worry about bleeding through the paper or smearing wet ink.

There are many advantages to working in a digital art studio: You never run out of paint or canvases. You don't have to worry about destroying your brushes if you don't clean them properly. You don't have to worry about the limits of your studio space. And you don't have to inhale toxic chemicals.

You have a palette of hundreds or even millions of colors (depending on your monitor) —that should suffice for most of your needs. You can work dry media over wet media, for example, pastels over oil paint, and other unusual combinations of media can be used in new ways. You can literally apply a medium to thousands of textures, and you can even select individual areas in a painting to emphasize, such as the scales on a fish or lizard.

In a digital studio, you also have the ability to try a vast array of effects on a painting without ever changing the original. Computer art tools allow you to explore other options without ever damaging a painting. And if you make a mistake, you can undo your last action. Try that with traditional media!

Computer art programs also enable you to view detail and composition simply by clicking your mouse. You can zoom into the most minute detail, then zoom all the way back to view your creation as if you were 10 feet away.

A BASIC ART LESSON

There are four basic things to consider when you are creating a piece of artwork:

- Composition
- Light and Shadow
- The Value Scale (Colors)
- Perspective

COMPOSITION

Composition of a picture refers to how you place the elements of your drawing. When composing your picture, you should consider object size and dimension, light source and shadows, colors, and the effect you wish to create.

Your ultimate goal is harmony: your picture should look unified. For example, you wouldn't want to mix too many objects where some are vertical and some are horizontal. That mixing would result in a disharmonious composition. You want artful placement and balance of the objects in your picture.

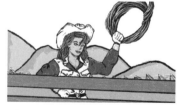

The subject of this painting is not perfectly centered, yet the composition is well balanced because of her arm reaching out with the coiled rope.

Contrary to some opinion, good composition does not require centering your main object. You can place your main object off center to great effect. However, balance is essential. If you place the main object on the left, balance that object on the right, though not necessarily with another large object. You can achieve effect balance with minor objects. For example, if your picture has a flower on the left side of the picture, you can balance that by sweeping the stem and some leaves to the right side. Or, if you have a horse on the left, balance with trees and distant hills on the right.

To compose your picture, first decide in general what you want to draw. Then sketch your idea. To test the composition, block out the picture with color patches, filling in basic color areas. Grass is green, a mountain is darker green, sky is blue. Take a look at how the colors work in unison. Once you have the desired composition, begin adding progressively more detail to the sketch.

In the second section of this book, we discuss several art projects that have been included on the disk. Take a look at how those pictures are created to get ideas on blocking out and coloring your images.

LIGHT AND SHADOW

In our three-dimensional world, the effects of light and shadow are immediate and dramatic. Light and shadow are vital elements of art, as well. In art, light and shadow create depth and mood.

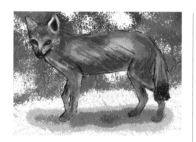

Light is used to highlight the coyote's coat. The shadow underneath him helps show that it's daytime.

Let's talk about light. Look around you where you are at this moment. Take a minute to notice how light affects everything you see. Where the rays hit an object directly, it's bright. Where the light is blocked, the object is shadowed. Note where the brights are the brightest and the where the shadows are darkest.

You've seen shadows and light patterns so often in your life that you might not be seeing them at all anymore. This pattern of bright and dark is on everything you see. Re-open your eyes as you move about your world and make an effort to notice the effect of light on the world around you. Light is what gives objects their shape. Notice in particular the boundaries between light and shadow. This is where the shadows tend to be darkest. The more intense the light source, the deeper the shadows.

When it comes time to paint or draw, try to remember what you've seen about how light creates bright spots and casts shadows. Try to work this effect into your work. You can use light and shadow for particular effects in your work, to add a specific emotion or dimension and reality. It's a tool. Use it or not, depending on your taste and goals.

THE VALUE SCALE

The phrase "value scale" refers to the tone of a color, from darkest to lightest. Blue is blue, but depending on the value of the color, it can be cobalt or sky blue.

The value scale ranges from 1 to 10, darkest to lightest. Let's take gray as an example. On the value scale, the gradation of gray ranges from black to white, and all values in between.

Contrast refers to the range of dark and light values in a painting. The greater the range, the greater the contrast. If you are using light and shadow, like we talked about above, you'll want to have contrasting values in the shadow so it stands out.

You can set the mood of a painting or drawing just by using color value. Dark colors are usually more ominous than light colors.

When starting out, try to have a good range of values in a painting. A good exercise for learning about value is to draw something that's monochromatic. That means to just use one color for the whole drawing and rely on value and contrast to define your subject. It's a good idea to start any painting with a sketch that not only indicates the shapes of your subjects, but their values as well, so you can get a good feel for their balance and the overall composition.

PERSPECTIVE

Like light and shadow, perspective is another tool to put into your skills kit. You can pull it out often, sometimes, or never. It all depends on your taste and goals. If you are painting in the primitive style, perspective won't be too important. If you are sketching a crowd at a party, perspective is important, unless you intentionally want an individual to look as large as a couch!

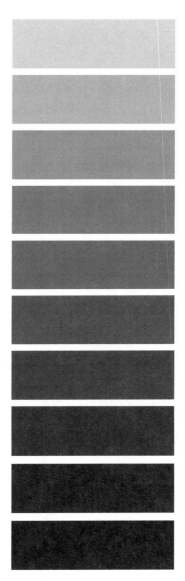

The value scale for black.

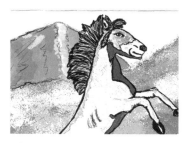

The mountain is really bigger than the horse, but in this painting the horse appears larger than the mountain to keep it in the proper perspective.

Perspective imitates the real world. The problem is, the real world is a weird place, as you might have noticed. For example, you look down parallelβ train tracks (that seem to meet in the distance) and see the flat front of a train engine. Over a period of time, the flat front of the engine gets larger and larger. Is this strange? It ought to be, but your brain takes it right in stride and processes the image. A train is moving toward you.

To mimic this strange phenomenon on a flat piece of paper, artists have developed a number of tricks, but the most fundamental one is this. To make something appear distant, make it smaller. Carry this rule to its logical conclusion and you'll see that very distant things are so tiny they vanish completely, just as they do in the real world. That vanishing act is translated onto the page in something called the vanishing point, which is a point you can actually put on paper. The vanishing point is the place on the horizon where things disappear.

When you look at things, keep an eye out for vanishing points. This will give you a better sense of perspective on the world around you. There are two kinds of perspective: one-point and two-point perspective.

If you look down a country lane and watch it disappear, you are seeing one vanishing point.

If you stand at the corner of a city block, you can see two vanishing points. One street disappears in one direction and the other disappears in a direction 90 degrees off.

Perspective is what makes a flat picture look three-dimensional. If objects seem close in front and far away in back, we have a sense of perspective. For example, draw a person in front of a mountain. If the person's head is over the mountain range, you have a sense that the person is closer than the mountain.

You can play with perspective by changing your point of view. View the world from the perch of a telephone wire, as a bird might. Or take the perspective of a mouse and view everything from the ground up. The rules of perspective apply no matter what your vantage point might be.

Experiment with perspective. You'll see the world in a whole new way!

HAVE FUN!

Now you know the basics. It's time to get started.

Relax for a moment. Understand that you have talent. Art is Personal Expression. Nobody else can paint or draw as you will. Trust that your expression is as valid as anyone else's. If you have something to express, do it. Don't worry about the quality. That comes with time.

Don't strain. Freely express yourself and your view of the world. Most importantly, have fun!

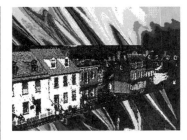

An example of one-point perspective where the vanishing point is off the page to the right.

HOW THIS BOOK CAN HELP YOU

INTRODUCTION

"Why would I ever need this book?" Sound familiar? Wasn't that one of your questions before you bought this book? The quick answer to that is —because it is so helpful it will make all of Dabbler's excellent features easy to understand and simple to use.

True, you could just jump into the program and hack your way through Dabbler. And you can use the online help that comes with the program. However, neither the manual nor the online help that comes with the program are designed to be as in-depth and comprehensive as this book. That's why we wrote this book.

Dabbler is an extraordinary program. But it will get lost in the maze of the zillion other drawing programs if its full power and features are not recognized. That's why you should read this book. It'll introduce you to Dabbler in an easy, paced way. Before you know it, you'll be expert at using the program.

IN THIS CHAPTER

- **Section One summary**
- **Section Two summary**

This book is divided into two sections:

- *Section One*: Using Dabbler explains the components that make up Dabbler, including the screen, tools, menus, sketchpads and flipbooks, and everything else.

- *Section Two*: Developing As An Artist takes you step by step through the process of creating various kinds of art using Dabbler. You learn to create a flipbook, how to create a logo, how to design your own screensaver, and lots more.

SECTION ONE: USING DABBLER

The chapters in this section build your Dabbler knowledge block by block, one chapter building on the other, so that by the end of the section you have a secure foundation with the program, which will then let you reach out and continue to create on your own with flair and assurance. The Section One chapters consist of:

CHAPTER 1: INTRODUCTION TO COMPUTER ART

This chapter provides a general introduction to computer art: tools, general drawing instructions, etc., and discusses a few of Dabbler's great features.

CHAPTER 2: HOW THIS BOOK CAN HELP YOU

This chapter briefly outlines how the book is designed (Section One and Two), the building-block theory, and presents a synopsis of each chapter.

CHAPTER 3: GETTING STARTED

This chapter discusses the hardware considerations and system requirements for using Dabbler. Once those are reviewed, you learn how to install, launch, and register the program.

CHAPTER 4: THE DABBLER SCREEN

This is your first introduction to the Dabbler screen, drawers, menus, and layout. Each component of the screen and the features are introduced here.

CHAPTER 5: SKETCHPAD

This chapter introduces the concept of Sketchpads, tells you how to create new or open an existing Sketchpad, and explains how to use and manage Sketchpads.

CHAPTER 6: FLIPBOOKS

Here you will learn all about Flipbooks, books that let you create animation. You'll learn how to create a flipbook, how to use the Flipbook options, and all about Flipbooks in general.

CHAPTER 7: THE TOOLS DRAWER

Dabbler comes with some great drawing and painting tools, all of which are stored in the Tools drawer. This chapter defines the tools and explains how to use each one. You really should read this chapter and follow the practice session, or you might miss out on some of Dabbler's great features.

CHAPTER 8: SELECTING YOUR CANVAS

This chapter introduces you to the concept of textured papers and how to use them. Leaping Lizard, you won't believe the textures you can choose from! You also learn about using Tracing Paper, a nifty way to create your own masterpiece from existing art. It's also very useful when you make a Flipbook.

CHAPTER 9: USING COLOR

Dabbler comes with a million colors you can choose from when you create your art. This chapter introduces you to the Color drawer, the Color Wheel, Color Palettes, and the Dropper Tool (the perfect color matcher). You'll also have a practice session on the use of color in your work.

CHAPTER 10: SPECIAL EFFECTS

This chapter goes into detail about Dabbler's special effects available in the Effects menu. You'll learn how to use each effect, and get to try out a few in a practice session. You'll also learn about Cloning, where a new creation is derived from an original source (yes, it's as frightening as it sounds!)

CHAPTER 11: RECORDING A SESSION

This chapter discusses how and why you would record a creative session for later playback. It also includes a practice session so you'll know what you're doing when you try it for real.

CHAPTER 12: OUTPUTTING YOUR ART

The final chapter in this section tells you how you can output your artwork, either through printing or through file export. A brief practice session runs you through the motions.

SECTION TWO: DEVELOPING AS AN ARTIST

This section illustrates, through step-by-step practice sessions, many of the different kinds of art you can create with Dabbler. This section goes a step beyond the basics and shows you how to get your money's worth from Dabbler by guiding you through a wide variety of projects. Each session is recorded for practice on CD-ROM.

CHAPTER 13: YOUR PERSONAL ART TUTOR

Using Dabbler's Tutor feature is like having your personal art instructor. This chapter introduces the Dabbler Tutor.

CHAPTER 14: CREATING AND ANIMATING A CARTOON

This chapter shows you how to create the illusion of movement using Flipbooks. Your subject: An octopus swimming on the ocean floor.

CHAPTER 15: CREATING A COLORING BOOK

Illustration subject: The Wild West. These illustrations are simple and include such subjects as a horse, a cowboy/girl, a coyote, a campfire, a Western boot, a

guitar, and a cow. We show you how easy it is to design a coloring book and we provide you with methods you can employ so you can use the coloring book repeatedly, without destroying the original art.

CHAPTER 16: CREATING A CALENDAR DESIGNED WITH YOUR ART

In this chapter you see how to create simple art to include in your personally designed calendar. We provide pictures for January through April. These are simple illustrations: January, a sled; February, a Valentine's heart; March, sneakers; April, an umbrella. We leave it up to you to design the remaining months.

CHAPTER 17: CREATING A LOGO

Here you see how easy it is to create a logo. The object of this exercise is to combine different elements, such as letterforms, graphics, and textures, to create a logo.

CHAPTER 18: CREATING YOUR OWN SCREEN SAVER

You can design your own screen saver. We show you how to do it in this chapter. Illustration subject: A mountain bicycler. Once you've created the picture, it can be added to After Dark, UnderWare, and other popular screen saver programs.

CHAPTER 19: CREATING A POSTER

Create-a-Poster 101. This chapter shows the elements that make a striking poster, with vivid colors and dynamic pictures. Illustration subject: Dinosaurs.

CHAPTER 20: CREATING A STILL LIFE

Yes, you can also create still lifes with Dabbler, as you see in this chapter. Illustration subject: Still life fruit bowl.

CHAPTER 21: CREATING A LANDSCAPE

Here you see how perspective and highlight and shadows can add dimension to your two-dimensional art. Illustration subject: Apple orchard.

CHAPTER 22: CREATING A PORTRAIT

Portrait painting is difficult in any medium, but it can be done on Dabbler as well as in oil or acrylic. Illustration subject: A basic female portrait. Mona was busy so we chose her lesser-known sister Hildy.

CHAPTER 23: TURNING PHOTOGRAPHS INTO ARTWORK

Yes, one artistic eye saw the image and captured it on film. Now you can take that image and render your own view of the same subject using the Clone feature. Illustration subject: Sleddville village street.

So, there you have it. Read the book from cover to cover, or read the first section and jump around in Section Two. Have fun exploring the world of Dabbler.

GETTING STARTED

INTRODUCTION

Dabbler is easy to install and easy to use. There are just a few technical considerations to cover before jumping in. If you already have Dabbler installed and running, you can skip this chapter.

IN THIS CHAPTER

 Technical considerations

 System requirements

Installing Dabbler

Macintosh installation

Windows installation

Starting Dabbler

Fractal Design

Dabbler™

by Mark Zimmer, Tom Hedges, John Derry, Matthew Kaufman & Shelby Moore

Tad Shelby
0048524-3791

FRACTAL DESIGN CORPORATION

Copyright ©1991-94 Fractal Design Corporation Aptos, CA. All Rights Reserved.

TECHNICAL CONSIDERATIONS

Dabbler is so natural to use, it's almost misleading to use the word "technical," but there are a few computer topics we need to cover before the fun starts.

SYSTEM REQUIREMENTS

Dabbler runs on most PCs running Windows and most Macintosh computer models. You must have a CD ROM drive.

 Macintosh. LC, II series, Performa, Centris, Quadra, PowerPC, and Powerbook models running System 6.0.5 or later.

 Windows. 386SX, 386, 486SX, 486, or Pentium IBM-compatible models running Windows 3.1 or later or Windows 95.

MONITOR

You don't need a color monitor, but you can obviously have more fun with one.

MEMORY

A hard drive and a minimum of 4MB of RAM is required, although you'll do much better with 8MB or more of RAM.

MOUSE OR DRAWING STYLUS

Dabbler must be used with a mouse, although you'll find it infinitely more enjoyable if you use a pressure-sensitive stylus. A *stylus* is a device that lets you draw in Dabbler as if you were using a pen or pencil, and a *pressure-sensitive stylus* reacts to how hard you press down when you draw.

INSTALLING DABBLER

Dabbler is shipped on CD-ROM for both the Macintosh and Windows.

These instructions assume you have a basic knowledge of how to navigate through your hard drive and perform basic operations, such as copying files, using dialog boxes, starting programs, and using a mouse. Please consult your system documentation if you have problems with these operations.

Macintosh installation

Follow these steps to install Dabbler on a Macintosh:

1. Insert the Dabbler CD-ROM into your CD drive. Double-click the **Dabbler 2.0 Installer** application icon to launch the installation program.

2. Click the **Continue** buttons on the two opening screens. If you have a PowerPC, select **PowerPC** from the next dialog box. If you have any other Macintosh model, select **680x0**.

3. Select the folder on your hard drive in which you'd like Dabbler installed, then click **Install**.

Step 1.

Windows installation

Make sure Windows is running and any other applications are closed, then follow these steps to install Dabbler for Windows:

1. Insert the Dabbler CD-ROM into your CD drive.

Step 2.

Step 3.

2 Open the Program Manager and select **Run...** from the File menu. The Run dialog box is displayed.

3 Type **d:\install** in the Command Line field. If your CD drive is not your d drive, substitute its letter for d.

4 Press the **Enter** key or click **OK**. The Dabbler installation window is displayed. Click **Continue** if you wish to continue with the installation, or **Exit** if you don't.

5 Dabbler automatically selects a drive and directory for the installation. If you'd like it placed in a different location, enter that location in the Install in Directory field. Click **OK**. The next screen asks you to confirm your choice.

You must exit then restart Windows before running Dabbler.

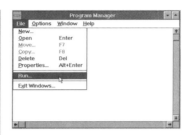

Step 2.

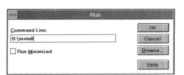

Step 3.

STARTING DABBLER

To start, or *launch*, Dabbler, simply double-click on its icon in the Dabbler folder (Macintosh) or program group (Windows).

LAUNCHING FOR THE FIRST TIME

The first time you launch Dabbler, you'll see a dialog box asking you to register your product. Enter your name and the serial number found on the back of Installation Disk 1 and your registration card. Click **OK**.

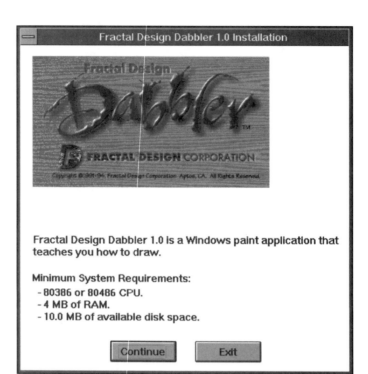

Step 4.

Fractal Design Dabbler 1.0 is a Windows paint application that teaches you how to draw.

Minimum System Requirements:
- 80386 or 80486 CPU.
- 4 MB of RAM.
- 10.0 MB of available disk space.

Continue Exit

Fractal Design Dabbler 1.0 Installation

Install from Drive \ Directory:

A:\

Install in Directory:

C:\DABBLER

Continue Exit

Step 5.

Step 5.

Step 6.

Personalize your copy of Dabbler

Enter your name

Enter the complete serial number from registration card (7 digits, a minus, and 4 digits)

OK

Registering Dabbler.

Another dialog box is displayed asking you to select any third-party Photoshop-compatible plug-ins. These are special-effects mini-applications created by companies other than Fractal Design Corp. If you have any of these special-effect drivers, select them here so they can be used with Dabbler. If you don't have any, select **Cancel**.

Now each time you double-click on the Dabbler icon, you'll go directly to the main screen. Dabbler opens up to the last sketchpad page you worked on. But before we go any further, we first need to cover Dabbler's basic tools.

Plug-ins ▼

Anti-Aliased PICT
Color Halftone
Crystallize
De-Interlace
Displacement Maps
Distortions
EPS JPEG
Extrude

Hard Drive

Eject
Desktop

Open
Cancel

Dabbler supports Adobe Photoshop plug-ins. Select a plug-in from Photoshop's plug-in folder. If you don't have Photoshop, select Cancel.

If you have Photoshop or any Photoshop-compatible plug-ins, select them in this dialog box so you can use them with Dabbler.

THE DABBLER SCREEN

INTRODUCTION

This chapter introduces you to the Dabbler screen and all of its components. Dabbler, simple and elegant as it is, will be much easier to use if you are familiar with the screen and where everything can be found on the screen.

IN THIS CHAPTER

 The Main Screen

 Setting Preferences

 The Dabbler Drawers

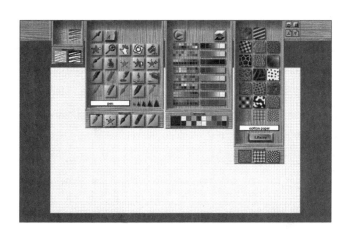

You will also find out how to set your preferences for the program, at least those preferences that Dabbler can accommodate!

Finally, the contents of the Dabbler drawers are described in brief. Other chapters discuss each drawer in detail.

THE MAIN SCREEN

The Dabbler screen is divided into three parts: the Menu bar, the Drawer bar, and the desktop.

MENU BAR

The menu bar consists of six menus: File, Edit, Effects, Options, Tutor, and Help.

File Menu

The File menu contains the typical File menu options: **Open**, **Close**, **Page Setup**, **Print Setup**, **Print**, and **Exit** (Windows) or **Quit** (Macintosh).

It also has some commands that are specific to Dabbler:

New Sketchpad...	
New Flipbook...	
Open...	Ctrl+O
Close	Ctrl+W
Import Page...	
Save Page As...	
Revert Page	
Acquire	
Export	
TWAIN Acquire...	
Select TWAIN Source...	
Page Setup...	
Print Setup	
Print...	Ctrl+P
Exit	Ctrl+Q

The File menu.

- **New Sketchpad** opens a new Sketchpad. Sketchpads are described in *Chapter 5, Sketchpads.*

- **New Flipbook** opens a new flipbook. Flipbooks are described in *Chapter 6, Flipbooks.*

- **Import Page** lets you bring in a page from another application and paste it on a Sketchpad page. Importing files is described in *Chapter 5, Sketchpads.*

- **Save Page As** lets you save a Sketchpad page separate from the Sketchpad. Saving files is discussed in *Chapter 5, Sketchpads*.

- **Revert Page** deletes all changes you have made to a Sketchpad page since it was last saved.

- **Acquire**... is for when you want to import an image directly from a scanner.

- **Export** lets you export a picture file to another program. Exporting files is discussed in *Chapter 12, Outputting Your Art*.

Edit Menu

The Edit menu contains many standard Edit menu items: **Undo**, **Cut**, **Copy**, **Paste**, **Clear**, and **Select All**.

The Dabbler edit commands are simple to use and understand:

- **Add Page** adds a page to the active Sketchpad, placing the new page before the current page.

- **Delete Pages** deletes the pages you specify in the Delete Page dialog box that is displayed when you choose this command.

- **Browse Pages** displays the Browse Pages box where you can look through your current Sketchpad. We talk about Browse Pages in *Chapter 5, Sketchpads*.

- **Go to Page** jumps you to a specific page in the current Sketchpad. You tell Dabbler the page and Dabbler opens the Sketchpad to that page.

Undo	Ctrl+Z
Cut	Ctrl+X
Copy	Ctrl+C
Paste	Ctrl+V
Clear	
Add Page	Ctrl+N
Delete Pages...	
Browse Pages...	
Go to Page...	
Select All	Ctrl+A
Deselect	Ctrl+D
Reselect	Ctrl+R
Set Preferences...	

The Edit menu.

- **Deselect** reverses the selection of an item.

- **Reselect** selects the item again after deselecting it.

- **Set Preferences** is where you set your Dabbler and Windows preferences. We talk about setting preferences in the *Setting Your Preferences* section later in this chapter.

Effects Menu

The Effects menu gives you another way to choose special effects options. Each of these options is also available in the Tools drawer. But this menu is a quick way to select an effect if you forget which icon corresponds to which effect.

Each of the effects is discussed in detail in *Chapter* 10, *Special Effects*.

- The **Fill** command lets you fill in a stencil area on your drawing. This quick method is described in *Chapter* 9, *Using Color*.

- The **Plug-in Filters** option is available if you have Photoshop or other application filters loaded to work with Dabbler. Use this command to select the filter you want to use.

Options Menu

The Options menu lets you select one or more of the Dabbler options:

Redo	Ctrl+Z
Cut	Ctrl+X
Copy	Ctrl+C
Paste	Ctrl+V
Clear	
Add Page	Ctrl+N
Delete Pages...	
Browse Pages...	
Go to Page...	
Select All	Ctrl+A
Deselect	Ctrl+D
Reselect	Ctrl+R
Set Preferences...	

The Effects menu.

- **Zoom Factor** lets you zoom in or out on the page. Normally, you look at the page at 100%, that is, full size. If you want to look at detail on the page, you can zoom in, up to 1200% (that's a lot of detail!). If you want to view the whole picture from a distance, you can zoom out, up to 8.3% of the picture (you'll need a telescope to see any detail from that distance!).

- The **Drawers** option lets you open drawers by command instead of by using the mouse to manually open the drawer. You can also close all drawers at once.

- **Draw Straight Lines** lets you draw straight lines with whatever tool you currently have active. To draw a line, click the cursor at the spot where you want the line to begin, move the cursor to where you want the line to end, and click. You can draw one or more line segments, connected or separate from one another. This option changes to **Draw Freehand** when you select it.

- **Draw Freehand** lets you draw freehand with whatever tool you're currently using. This option changes to **Draw Straight Lines** when you select it.

- **Tracing Paper** places a piece of tracing paper over the current page. You can select tracing paper in this menu or click on the **Tracing Paper** icon on the Drawer bar. We talk about tracing paper in *Chapter 8, Selecting Your Canvas*.

<u>Z</u>oom Factor	▶
<u>D</u>rawers	▶
Draw <u>S</u>traight Lines	Ctrl+K
<u>T</u>racing Paper	Ctrl+T
Invert Stencil	
Invert <u>P</u>aper Texture	
Te<u>x</u>t Styles...	
Flipbook Options...	
Sessio<u>n</u>s...	
Annotate Session...	

The Options menu.

- **Invert Stencil** toggles the stencil from **Fill Inside** to **Fill Outside**. Stencils are discussed in *Chapter 7, The Tools Drawer.*

- **Invert Paper Texture** reverses the bumps and valleys of each texture. You can switch back and forth between reversed texture effects using this option.

- **Text Styles** lets you choose the typeface style and size for any text you place on your work. We talk about type in *Chapter 10, Special Effects.*

- **Flipbook Options** lets you select the setup options for the current flipbook. You'll learn more about this great feature in *Chapter 6, Flipbooks.*

- **Sessions** lets you replay any recorded drawing session files, either sessions you have saved or session files from someone else. At any time during the session, you can stop the replay and proceed to add your own touch to the incomplete drawing. We talk about sessions a lot more in *Chapter 11, Recording A Session.*

- **Annotate Session...** lets you add text below a session screen to give information to the viewer.

Tutors Menu

The Tutors menu is where you choose which tutor you would like to work with. You have a tutor who teaches you to draw cartoons, one who teaches you to animate cartoons, and another who tells you how to use Dabbler (as if this book weren't enough!).

You can also load other Tutor files if you have them.

We discuss Tutor sessions in *Chapter 13, Your Personal Art Tutor*.

You can also access the Dabbler on-line documentation in the Tutors menu.

HELP MENU

The Help menu is pretty easy to figure out. If you need help and can't find your answers here, call on the experts . . . look at the Dabbler online help.

SETTING YOUR PREFERENCES

Dabbler lets you set your preferences for the color and orientation of the drawing cursor, the mouse control sensitivity, whether or not to have sound effects when you use the program, and a couple of other controls.

You set these preferences using the **Set Preferences** command on the Edit menu, entering preferences in Dabbler's Set Preferences box.

- In the **Drawing Cursor** box, you can select the cursor orientation and color.

- The **Sound Controls** let you choose whether or not to have sound when you open and close drawers and when you draw. If you want sound, you can select the volume of the sound, as well.

- The **Mouse Control** lets you dictate the mouse pressure. If you are ham-handed, you might want a lighter pressure than if you draw with a flick of your wrist.

> **Cartoon Animation**
> **Drawing Cartoons**
> **How To Use Dabbler**
> **Load Other...**

The Tutors menu.

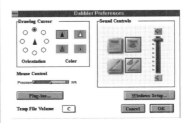

The Preferences dialog box.

- The **Plug-Ins** option lets you select any Photoshop graphics effects plug-ins you'd like to use with Dabbler. You choose the plug-ins as you would choose a file from any file list.

- You set the drive for your temporary file storage in the **Temp File Volume** box. The default setting is the C drive.

- If you click the **Windows Setup** option, Dabbler displays the Windows Options dialog box. Use this box to set your physical memory usage preferences, your printing preferences, and your display preferences. See the online help for more specific information about these settings.

Once you have set your preferences, click **OK**.

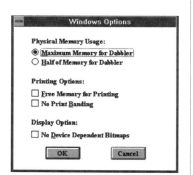

The Options dialog box

THE DABBLER DRAWERS

As you can see, the Dabbler screen is designed to make you feel like you're sitting at your desk while you create your artwork. And sitting at your desk, you'd like to have all of your tools and papers easily at hand, wouldn't you? Dabbler understands that.

The four drawers at the top of the screen hold all of your art tools and papers. Better yet, just so you don't have to search through each drawer looking for a particular tool like you might have to in a real desk, the Dabbler drawers are already organized for you:

- The first drawer is the **Extras** drawer. The contents of this drawer change, depending on the tool you are using. Some tools have options, or extras,

to select from when you use the tool. For example, if you select the **Pen** tool, you have two extras, the **Scratchboard Pen** and the **Ballpoint Pen**. If a tool has no extras, this drawer is empty.

- The **Tools** drawer is where most of the fun is. In this drawer you'll find all of Dabbler's painting and drawing tools, and most special effect tools.

- The **Colors** drawer contains your 16-million-color palette (not all monitors and graphics cards support 16 million colors). Painting and drawing would be pretty boring if you could only use black. The **Colors** drawer relieves the tedium of limited choice.

- The **Papers** drawer holds 20 paper texture choices. When you use textured paper with pencils and chalk, the texture of the paper shows in the drawing. The great thing is, with Dabbler you can use several textures on a single page. You can also reverse the paper texture, and get two textures from one.

To the right of the four drawers are the four paper icons:

- The top left icon is the **Clone** icon. Cloning lets you create an image from a photograph that looks like it was hand painted by taking color information from one page and transferring it to another through the painting tools. Cloning is discussed in detail in *Chapter 10, Special Effects*.

- The top right icon is the **Tracing Paper** icon. Select this icon to choose the tracing paper option. To cancel the selection, click the icon

The Dabbler screen with its drawers closed.

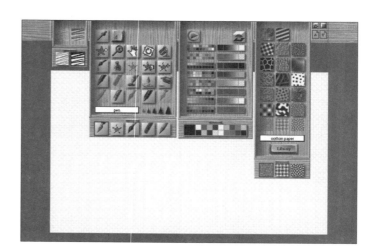

The Dabbler screen with its drawers opened.

again. Tracing paper is explained later in *Chapter 8, Selecting Your Canvas*.

The paper icons.

- The bottom left icon is the **Previous Page** icon. Click this icon to scroll through the previous pages in your current Sketchpad.

- The bottom right icon is the **Next Page** icon. Click this icon to scroll through the following pages in your current Sketchpad.

OPENING AND CLOSING DRAWERS

It's simple to open the Dabbler drawers. Just put the cursor on the drawer handle (the cursor changes to a hand) and click. The drawer opens.

To close a drawer, click on the handle again. If the sound option is turned on, you will hear the drawer slide in and out.

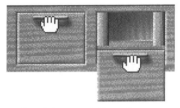

A closed drawer *(left) and an open* drawer *(right)*.

CHOOSING ITEMS FROM DRAWERS

Let's say you want to choose the chalk from the Tools drawer. To get the chalk, you'd have to:

1. Open the drawer.

2. Click on the Chalk tool icon. The chalk is selected and the word "chalk" is shown in the tool name box.

You'll notice that the chalk icon is now shown on the face of the drawer and has a red box around it. That red box tells you that tool is selected.

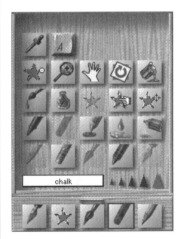

Selecting the Chalk tool.

The Tools drawer with the five most recently used tool icons on the drawer face.

Dabbler displays the last items selected on each drawer face (below the handle). If a tool has an extra associated with it, Dabbler automatically chooses one extra for you when you select that tool. The extras are shown on the face of the Extras drawer. The colors and the paper textures are also shown on the face of their drawers. Items placed on the drawer face are "grayed out" or dimmed inside the drawer.

To replace a specific tool on the drawer face, open the Tools drawer, click on the replacement tool icon in the drawer and, holding down the mouse button, drag the icon over the tool you want to replace. Release the mouse button. The replacement tool icon is now on the drawer face and the other tool is back in the drawer.

SKETCHPADS

INTRODUCTION

When you draw in Dabbler, you have the choice of drawing either on a Sketchpad or in a flipbook:

> A Sketchpad is a set of pages bound together, much like a traditional Sketchpad.

IN THIS CHAPTER

- **What are Sketchpads?**
- **Opening a new Sketchpad**
- **Opening an existing Sketchpad**
- **Saving pages as individual files**
- **Importing files to a Sketchpad**
- **Managing your Sketchpads**

> A Flipbook is a series of pages that, when flipped through to rapidly display the images, mimics animation.

This chapter discusses the Dabbler Sketchpads in detail. Chapter 7 discusses Flipbooks and flipbook animation.

WHAT ARE SKETCHPADS?

Dabbler uses Sketchpads to hold your artwork pages. When you draw in Dabbler it's like drawing in a Sketchpad, or in any one of your numerous Sketchpads.

Each blank sheet is presented as a page on your Dabbler Sketchpad. You can flip forward or backward through a Sketchpad to view the different pages. You can also add pages or delete pages. You can even move pages within the Sketchpad. And last, but not least, you can also add sheets of tracing paper within the pad. Quite versatile and very handy, these Sketchpads.

One of the benefits of Sketchpads is that they help you organize your work. Each Sketchpad is saved as a separate file, automatically. Once you have named a Sketchpad, you never have to worry about saving the file again. Dabbler updates the file at the end of each Dabbler session for you, storing the files in the Sketchpad file.

For example, you can have one Sketchpad for still life drawings, one for animals, another for airplanes, still another for fish. When you create a drawing on a Sketchpad page, Dabbler automatically saves the drawing to that Sketchpad file.

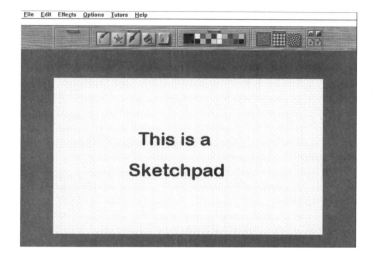

A *Sketchpad*.

A *Flipbook*.

OPENING A NEW SKETCHPAD

When you first open Dabbler, the screen is displayed with no page shown on the desktop.

Before you can begin to draw or paint, you must first open a Sketchpad. Dabbler lets you create as many Sketchpads as you want. The only limit is the amount of disk space you have on your computer.

To open a new Sketchpad:

The New Sketchpad dialog box.

1. Choose **New Sketchpad** from the File menu. Dabbler displays the New Sketchpad dialog box. This box tells you the size of the Sketchpad, the resolution of the image, the paper color, and the number of pages.

 Each new Sketchpad has 14 pages. You'll see later how easy it is to add pages, delete pages, or even move pages within a Sketchpad.

2. Set the options for the new Sketchpad:

 Width and Height. Dabbler enters default settings of 640 pixels (dots) by 384 pixels to fit the average screen at a 72 pixels per inch. If you want your Sketchpad to be a different size, increase or decrease the values in these fields.

 Resolution. The number of pixels your image has in each inch is known as resolution. Although your drawings look smooth, they are actually made up of very small dots.

The default is 72 pixels per inch, which means your picture has 72 dots to every linear inch. Pictures at this setting look pretty smooth on screen but will probably print roughly, with perceptible dots creating the picture.

A higher resolution value gives you a smoother print. Check the manual for your printer to see what the best resolution is for your picture.

Size. The number at the top of the box tells you how much of your computer's memory space each page in the Sketchpad will use. When you increase the width, height, or resolution of a Sketchpad, the size increases.

Paper Color. When you first use Dabbler, each Sketchpad page is white. If you wish to use other colors, click on the **Paper Color** button. Dabbler displays the Color dialog box.

The Color dialog box.

Select the color you want to use (see Chapter 8, *Using Color*, for more information), click **OK**. The new background page color is displayed in the Sketchpad preview window.

3 When all of the fields in the dialog box are correct, click **OK**. Dabbler displays the Sketchpad Name dialog box.

4 Name the Sketchpad and choose the disk location where you'd like the files stored.

The Enter Sketchpad Name dialog box.

By default, Dabbler names the first Sketchpad dabbler.pad and places the Sketchpad files in the Dabbler2 directory or folder, but you can rename the pads and save them anywhere you wish on your hard drive.

5. Click **OK** when you have a name and location selected.

Dabbler displays the first page of the new Sketchpad on the Dabbler desktop.

OPENING AN EXISTING SKETCHPAD

Once you have saved several Sketchpads, you have your choice of which pad to work in.

To open an existing Sketchpad:

The Open Sketchpad File dialog box.

Choose **Open** from the File menu. Dabbler displays the Open Sketchpad File dialog box.

Dabbler displays a thumbnail image of the first page of the selected Sketchpad in the Preview window.

You can flip through the pages of the Sketchpad by clicking on the pages in the Preview window. This is handy if you're not sure which Sketchpad has a particular drawing you are looking for.

Under the Preview window Dabbler displays information about the height and width of the Sketchpad, and number of pages.

2 If you want to preview more than one Sketchpad at a time, click **Browse**. Dabbler shows you thumbnail previews of all the Sketchpads in the current folder (Mac) or directory (Windows).

You cannot flip through the Sketchpad pages in this Preview window.

Browsing through the Sketchpads in a directory or folder.

3 To go back to the Open Sketchbook File dialog box to search another directory, choose **Cancel**.

4 Select the Sketchpad you want, then click **Open**. Dabbler displays the first page of the selected Sketchpad.

SAVING PAGES AS INDIVIDUAL FILES

You can save individual Sketchpad pages as individual files and open these files again when working with a Sketchpad. You would save a page as an individual file if, for example, you wished to export that page to another application.

To save a Sketchpad page as an individual file:

1 Click on the page you want to save.

2 Choose **Save Page As** from the File menu. Dabbler displays the Save Page As dialog box.

In the dialog box, enter a name and select a file type from the List Files of Type list box:

The Save Page As dialog box.

RIFF (raster image file format) is Dabbler's own file format. It can also be opened by Fractal Design Painter and Sketcher. To save space on your hard drive, don't select the Uncompressed option.

TIFF (tagged image file format) is a popular graphics format that saves files by remembering the color and location of each pixel. This format is compatible with Macintosh, Windows, DOS, and NeXT computer systems.

PICT is primarily a Macintosh format that uses QuickDraw routines to save a file. PICT is the format used by the Macintosh clipboard.

PSD refers to the native file format for the Adobe Photoshop application.

BMP (bitmap) is primarily a Windows format. BMP is the main format used by the Windows clipboard.

PCX (picture exchange) is primarily a Windows format used by many scanners and painting programs.

Targa is a file format for many high-end Windows painting programs.

IMPORTING FILES TO A SKETCHPAD

You can also import individual files to a Sketchpad.

To add a file page:

1. Turn to the place in the Sketchpad where you want to add the page.

2. Select **Open** from the File menu. Dabbler displays a file selection dialog box.

3. Find the file you want to add. If a thumbnail version of the image exists, it will be shown in the Preview box.

4. Click **OK**. That picture is now added as a page in your Sketchpad, placed before the page the Sketchpad was opened to.

MANAGING YOUR SKETCHPADS

Use the **Browse Pages** command in the Edit menu to manage each Sketchpad.

When you choose **Browse Pages** from the Edit menu. Dabbler displays the Browse Sketchpad dialog box.

To turn the Sketchpad pages:

1. Click on the bottom page of the Sketchpad to turn from front to back through the pad.

2. Click on the upper page of the Sketchpad to turn the pages from back to front.

When a Sketchpad is open, you can turn pages by clicking on the page icons to the right of the drawers.

To add a new page to the Sketchpad:

1. Turn to the page in the Sketchpad where you want to add a new page.

Browsing through Sketchpad pages.

2 Drag a piece of paper from the Paper Stack onto the Sketchpad. The new sheet is added in front of the current page.

When a Sketchpad is open, you can add a page by choosing Add Page from the Edit menu. The new page will be placed in front of the current page.

To delete a page from the Sketchpad:

1 Select the page you want to delete.

2 Drag the page to the Trash Can. If the sound option is turned on, you will hear the satisfying sound of paper being crumpled and tossed into the Trash Can.

When a Sketchpad is open, you can delete pages by choosing Delete Pages from the Edit menu. Dabbler displays the Delete Pages dialog box. Select the pages to delete and click OK.

Deleting pages from a Sketchpad.

To move a page within the Sketchpad:

1 Select the page you want to move.

2 Drag the page onto the Tack. The page will hang from the Tack.

3 Turn the Sketchpad to the page where you want to place the tacked page. The tacked page will be placed in front of the current page.

4 Drag the page from the Tack onto the Sketchpad.

When a Sketchpad is open, it is simplest to move a page by using the Browse Pages dialog box.

To save a page:

1 Select the page you want to save.

2 Drag the page from the Sketchpad to the File Folder. Dabbler displays the File Save dialog box. Enter a name and location where you want the file saved.

When a Sketchpad is open, you save a page by following the method described above in Saving Pages As Individual Files.

That's it for Sketchpads. It's all pretty straightforward. Now, let's talk about flipbooks, your gateway to animation.

FLIPBOOKS

INTRODUCTION

When you draw in Dabbler, you have the choice of drawing either on a Sketchpad or in a Flipbook:

- A **Sketchpad** is a set of pages bound together, much like a real sketchpad.

- A **Flipbook** is a series of frames that, when flipped through rapidly, mimics animation.

This chapter discusses the Dabbler Flipbooks in detail. Chapter 5 discusses Sketchpads.

IN THIS CHAPTER

- **What are flipbooks?**
- **Creating new flipbooks**
- **Opening a flipbook**
- **Saving individual frames**
- **Managing flipbooks**
- **Flipbook controls**
- **Playing back flipbooks**
- **Flipbook options**
- **Importing frames**
- **Exporting flipbooks**
- **Printing flipbooks**

A *Flipbook*.

WHAT ARE FLIPBOOKS?

Flipbooks are a series of pictures bound together where each picture (frame) is slightly different from the frames that come immediately before and after it. If the frames are viewed in sequence, something happens in the picture, frame by frame. When the frames are viewed quickly, by flipping the frames, the actions suggest motion rather than as minute changes seen frame by frame.

Maybe you remember a flipbook you saw as a child. For instance, did you ever see the flipbook where a frog sitting on a lily pad flicks its tongue out and captures a fly? Flipbooks are the first step towards animation.

As with Sketchpads, any work done in a Dabbler Flipbook is automatically saved to a specific Flipbook file when you quit the program. These Flipbook files have the file name suffix .fbk in the Windows environment.

CREATING A NEW FLIPBOOK

Before you can begin to draw or paint in a Flipbook, you must first create the Flipbook. Dabbler lets you create as many Flipbooks as you want. The only limit is the amount of disk space you have on your computer.

NEW FLIPBOOKS

Choose **New Flipbook** from the File menu. Dabbler displays the New Flipbook dialog box. This box tells you the size of the Flipbook, the maximum frame size, the paper color, and the number of frames in the book.

Each new Flipbook initially has 14 frames. You'll see later how easy it is to add frames, delete frames, or even move frames within a Flipbook.

FLIPBOOK SETTINGS

Set the options for the new Flipbook:

Starting a new Flipbook.

Width and Height. Dabbler enters default settings of 320 pixels (dots) by 240 pixels. If you want your Flipbook to be a different size, increase or decrease the values in these fields. You can also choose different units for the value: inches, centimeters, points, picas, or columns.

The maximum **Frame Size** is 320 x 320 pixels.

Size. The number at the top of the box tells you how much of your computer's memory space each frame in the Flipbook will use. When you increase the width or height, the size increases.

Paper Color. When you first use Dabbler, each Flipbook frame is white. If you wish to use other colors, click on the Paper Color button. Dabbler displays the Paper Color Selection window.

Select the color you want to use (see Chapter 9, *Using Color*, for more information), click **OK**. The new background frame color is displayed in the Flipbook preview window.

Naming a Flipbook.

When all of the fields in the dialog box are correct, click **OK**. Dabbler displays the Enter Flipbook Name dialog box.

Name the Flipbook and choose the drive and directory where you'd like the files stored. By default, Dabbler gives all Flipbooks the suffix .fbk. You can name the Flipbooks and save them anywhere you wish on your hard drive.

Click **OK** when you have a name and location selected.

Dabbler displays the first frame of the new Flipbook on the Dabbler desktop. At this point, you are ready to begin creating your own Flipbook.

OPENING AN EXISTING FLIPBOOK

Once you have saved several Flipbooks, you have your choice of which one to work in.

To open an existing Flipbook:

1. Choose **Open** from the File menu. Dabbler displays the Open Sketchpad File dialog box.

2. Find and select (click on once) a Flipbook. If the Flipbook list is not displayed, you may have to look in a different folder or directory. You can also choose different units for the value: inches, centimeters, points, picas, or columns. You can select your Flipbook from that list.

The first frame of a new
Flipbook.

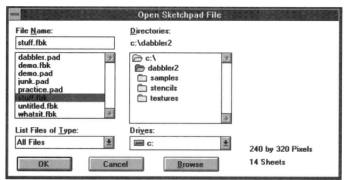

Opening an existing
Flipbook.

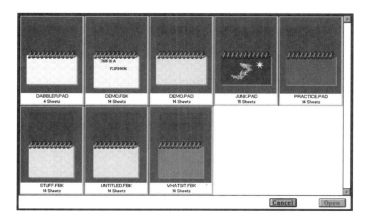

Browsing through your
Flipbooks.

Dabbler displays a thumbnail image of the first frame of the selected Flipbook in the Preview window.

You can flip through the frames of the Flipbook by clicking on the frames in the Preview window.

4 If you want to preview more than one Flipbook at a time, click **Browse**. Dabbler shows you thumbnail previews of all the Flipbooks in the current folder (Mac) or directory (Windows).

You cannot flip through the Flipbook frames in this Preview window.

5 To go back to the Open Sketchpad File dialog box to search another directory, choose **Cancel**.

6 Select the Flipbook you want, then click **Open**. Dabbler displays the first frame of the selected Flipbook.

SAVING FRAMES AS INDIVIDUAL FILES

You can save individual Flipbook frames as individual files and open these files again when working with a Flipbook. You would save a frame as an individual file if you wished to export that frame to another application.

To save a Flipbook frame as an individual file:

1 Click on the frame you want to save.

2 Choose **Save Frame As** from the File menu. Dabbler displays the Save Image As dialog box.

In the dialog box, enter a name and location and select one of the following seven file types from the List Files of Type list box:

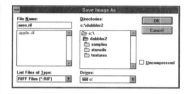

Use the Save Image As dialog box to save a Flipbook frame to an individual file.

- **RIFF** (raster image file format) is Dabbler's own file format. It can also be opened by Fractal Design Painter and Sketcher. To save space on your hard drive, *don't* select the **Uncompressed** option.

- **TIFF** (tagged image file format) is a popular graphics format that saves files by remembering the color and location of each pixel. This format is compatible with Macintosh, Windows, DOS, and NeXT computer systems.

- **PICT** is primarily a Macintosh format that uses QuickDraw routines to save a file. PICT is the format used by the Macintosh clipboard.

- **PSD** refers to the native file format for the Adobe Photoshop application.

- **BMP** (bitmap) is primarily a Windows format. BMP is the main format used by the Windows clipboard.

- **PCX** (picture exchange) is primarily a Windows format used by many scanners and painting programs.

- **Targa** is a file format for many high-end Windows painting programs.

Browsing Flipbook frames.

MANAGING YOUR FLIPBOOKS

The Browse Frames command in the Edit menu comes in handy when you want to rearrange frames in a Flipbook, or if you want to add or delete pages, or even save a frame as a file.

When you choose Browse Frames from the Edit menu Dabbler displays the Browse Frames dialog box. Here you can do all the Flipbook management things without having to use individual commands. It's drag and drop at its best!

To turn the Flipbook frames:

1. Click on the bottom frame of the Flipbook to turn from front to back through the book.

2. Click on the upper frame of the Flipbook to turn the frames from back to front.

When a Flipbook is open, you can turn frames by clicking on the page icons to the right of the drawers.

To add a new frame to the Flipbook:

1. Turn to the frame in the Flipbook where you want to add a new frame.

2. Drag a piece of paper from the Paper Stack onto the Flipbook. The new sheet is added in front of the current frame.

When a Flipbook is open, you can add a frame by choosing Add Frame from the Edit menu. The new frame will be placed in front of the current frame.

To delete a frame from the Flipbook:

1 Select the frame you want to delete.

2 Drag the frame to the Trash Can. If the sound option is turned on, you will hear the satisfying sound of paper being crumpled and tossed into the Trash Can.

When a Flipbook is open, you can delete frames by choosing Delete Frames from the Edit menu. Dabbler displays the Delete Frames dialog box. Select the frames to delete and click OK.

To move a frame within the Flipbook:

1 Select the frame you want to move.

2 Drag the frame onto the Tack. The frame will hang from the Tack.

3 Turn the Flipbook to the frame where you want to place the tacked frame. The tacked frame will be placed in front of the current frame.

4 Drag the frame from the Tack onto the Flipbook.

When a Flipbook is open, it is simplest to move a frame by using the Browse Frames dialog box.

To save a frame:

1 Select the frame you want to save.

2 Drag the frame from the Flipbook to the File Folder. Dabbler displays the Save Image As dialog box. Enter a name and location where you want the file saved.

Deleting Flipbook frames.

When a Flipbook is open, you save a frame by following the method described above in "Saving Frames As Individual Files."

FLIPBOOK CONTROLS

The Flipbook Control Bar

When a Flipbook is opened it appears with a Control Bar at the bottom of the screen. Use the Control Bar to move through the pages and play your Flipbook.

First Page. The first button on the left turns the Flipbook to the first page of the book.

Frame Back. The second button turns a frame back, to one frame earlier than the current frame.

Playback. The third button stops the Flipbook playback.

Play. The fourth button begins the Flipbook playback.

Frame Forward. The fifth button jumps the Flipbook forward a frame, to the frame after the current frame.

Last Page. The last button turns the Flipbook to the last page of the book.

The bottom half of the Control Bar controls the playback speed.

This portion of the Control Bar can be displayed or hidden by clicking on the Maximize/Minimize button on the Control Bar title bar (Windows) or the Zoom button (Macintosh).

PLAYING BACK A FLIPBOOK

Part of the fun of creating Flipbooks is being able to watch the animation you have created. You can print the images, making hand-held Flipbooks. That's a great option for sharing the work. But before you print, you can also preview the book using Dabbler's Playback feature.

The Playback feature lets you see the progress of your animation and the results of the entire sequence.

To playback the Flipbook at any time

1. Make sure the Flipbook Control Panel is displayed.

2. Set the speed of the playback, moving the speed set slider bar to the left to slow the speed and to the right to increase the speed.

3. Click the **Play** button on the Control Panel. Dabbler will begin "flipping" the pages at the indicated speed.

You'll probably amaze yourself the first time you try this, so beware!

FLIPBOOK OPTIONS

When drawing frame-by-frame animation, it is helpful to reference previous frames. The Dabbler Flipbook Options allow you to control the number of tracing layers visible in front of and behind the current frame.

To control the number of transparent pages in a Flipbook:

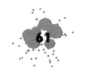

1. Select **Flipbook Options** from the Options menu. Dabbler displays the Flipbook Options dialog box.

2. Select the number of transparent pages you want. You may choose to view as many as 4 pages, including the current frame, dividing the remaining either in front or behind the current frame.

3. To see through the transparent pages, click the **Tracing Paper** icon to the right of the **Papers** drawer. You will see the current page through the layer of transparent pages you indicated.

4. Check the **Loop Playback** option to have the Flipbook playback repeatedly.

5. Use the Control Panel to set the playback speed.

IMPORTING FRAMES TO A FLIPBOOK

You can also import individual pictures to a Flipbook.

To add a picture:

1. Turn to the place in the Flipbook where you want to add the frame.

2. Select **Import Frame** from the File menu. Dabbler displays the Select Image dialog box.

3. Find the image you want to add. If a thumbnail version of the image exists, it

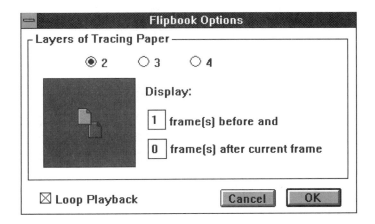

Setting Flipbook options.

Tracing Paper lets you see through to the next image. **Loop Playback** plays your Flipbook over and over.

will be shown in the Preview box. If you don't find the image you want, click the **Browse** button. Dabbler displays the Browse Image dialog box.

Click **OK** when you find the image you want to import. That image is now added as a frame in your Flipbook, placed before the frame the Flipbook was opened to. You can move the image within the Flipbook using the Browse Frames dialog box (see next).

EXPORTING FLIPBOOKS

You can export your Flipbooks as QuickTime or Video For Windows (.avi) files.

To export a Flipbook:

Select **Export** from the File menu to save your animation as a digital movie. Dabbler displays the Revert Frame dialog box.

Name the Flipbook and choose the disk location where you want to save it.

Click **OK**.

PRINTING FLIPBOOKS

Once you have designed your Flipbook, you'll probably want to print it, since half the fun of creating the thing is to show it to others. Dabbler lets you choose the size and binding dimensions of the hand-held Flipbook you will print.

Adding an image to a Flipbook.

Browsing through images to add to a Flipbook.

Exporting a Flipbook.

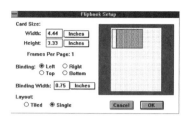

Setting Flipbook print options.

To print a Flipbook:

Choose **Flipbook Setup** from the File menu.

Fill in the setup values you want:

🐾 **CardSize** is the printed size of the Flipbook. Units can be in inches or centimeters. The default size is a fairly standard, reliable card size to use.

🐾 The **Frames Per Page** limit is set by the Layout selection at the bottom of the dialog box.

🐾 If you choose **Tiled**, Dabbler prints multiple frames on a single sheet of paper. The **Frames Per Page** indicates the maximum number of frames that can be printed on a page.

🐾 If you choose **Single**, only one frame is printed per page.

🐾 **Binding** controls where the Flipbooks are stapled, either at the Left, Right, Top, or Bottom. You decide.

🐾 **Binding Width** sets the amount of white space for the binding. You don't want the binding to be too small or some of the frame image might get lost in the binding.

After setting the Flipbook Setup options, select **Print** from the File menu

Page numbers are printed in the binding area to help with assembly.

For more information on printing your artwork, see Chapter 12, *Outputting Your Art.*

THE TOOLS DRAWER

INTRODUCTION

As you may have discovered in your previous experiences with art, the right tools can make the project a joy or a disaster. If the paper isn't right for your medium or the chalk or crayons are old and stubby, the painting or drawing can easily be ruined.

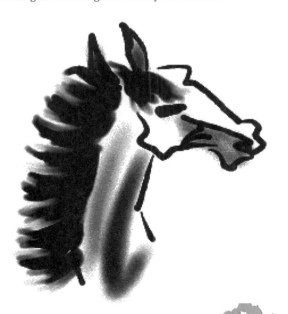

IN THIS CHAPTER

- Introduction
- Tools drawer icons
- Drawing and painting tools
- Stencils
- Adding text to your artwork
- Utility tools
- Practice session

With Dabbler, these potential hazards become obsolete. The tools are always perfect and there are several tools to choose from for just the effect you seek.

This chapter introduces the Dabbler tools, the painting and drawing tools, the text tool, and the utilities tools. At the end of the chapter you can follow the practice tutorial using some of the Dabbler tools.

THE TOOLS DRAWER

Let's take a look at the Dabbler art tools. Open the Tools drawer.

The Tools drawer contains icons for all of Dabbler's paint and drawing, text, and utility tools. The name of the currently selected tool is shown in the **Tool Name** box in the bottom row of the drawer, next to the five tip size selection icons (the triangles).

DRAWING AND PAINTING TOOLS

Dabbler has 14 drawing and painting tools, five of which have extras associated with them. The remaining eight icons are utility tools. These are discussed in later chapters.

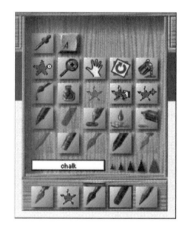

The opened Tools drawer.

 Pencil produces the same effect as traditional pencils. This tool has two extras:

 2B Pencil works just like a soft-lead pencil.

 Color Pencil generates the same effect as traditional colored pencils, with a thicker, more textured stroke.

 Eraser. Oh $(*##@!!!! You just misdrew a line. No problem, just erase it. Erase all you want—you won't tear the paper. Dabbler gives you two kinds of Eraser extras:

 Flat Eraser erases with hard-lined edges. This tool erases down to the paper no matter how much pressure you apply to your stylus.

 Soft Eraser erases with soft, fuzzier edges. If you have a pressure-sensitive stylus, you erase more paint when you press hard and less paint when you press lightly.

 Brush paints like an oil- or acrylic-paint brush.

 Crayon draws with waxy strokes that build up on each other, like the traditional ones. But press as hard as you want with these crayons; they won't break.

 Pen draws just like a regular ink pen, but with no leaking, splattering, or clogging. The **Pen** tool has two extras:

 Scratchboard Pen draws with a fine tip and smooth ink, like a fountain pen.

 Ballpoint Pen gives you lines like a ballpoint pen, with a thicker stroke and a bit of a rougher feel than the **Scratchboard Pen**.

*Strokes from the **2B Pencil** (left) and **Color Pencil** (right).*

*Strokes from the **Flat Eraser** (left) and **Soft Eraser** (right).*

*Strokes from the **Scratchboard Pen** (left) and **Ballpoint Pen** (right).*

*Strokes from the **Marker** tool.*

 Marker works like a felt-tipped pen, and won't dry out when you leave the cap off. They bleed when mixed with other strokes.

 Chalk draws like traditional pastels and charcoal, but with no smudged fingers or chalk dust to get on your clothes. You'll really see the paper texture with this tool.

 Oil Paint has two extras that paint with multiple colors using the brush types of the old masters.

 Impressionist Brush lets you emulate the French Impressionist painters. It lays down many short, multi-colored strokes to achieve this effect.

 Seurat Brush paints with little dabs of color to produce the pointillist technique developed by Georges Seurat.

 Water Drop smudges paint and colors, without dirtying your fingers. This tool only smudges, it does not apply any new color to your artwork. **Water Drop** has three extras:

 Frosty Water smears paint letting some paper texture show through.

 Regular Water smudges paint with smooth, clean strokes. No paper texture shows through when you use this tool.

Strokes from the **Brush** *tool.*

Strokes from the **Crayon** *tool.*

The chalk tool reacts very well to paper texture. This illustration shows the chalk tool used with a number of textures.

Strokes from the **Impressionist Brush** (left) and **Seurat Brush** (right).

Strokes from the **Liquid Brush** tool.

Strokes from the **Ink Bottle** tool using different tip sizes: small (left), medium (center), and large (right).

*Strokes from the **Frosty Water** (left), **Regular Water** (center), and **Grainy Water** (right).*

*Strokes from the **Spray Paint** tool.*

Grainy Water is somewhere in between **Frosty Water** and **Regular Water**, letting some, but not all, paper texture show through smudging.

Spray Paint sprays color like an airbrush or a can of spray paint, giving you very soft edges.

Liquid Brush treats your painting as if it were very wet. It moves paint around as if you were dragging a wet brush through it or as if you were finger painting, and can give you some very cool distorted effects.

Ink Bottle sprays drops of ink on your paintings. If you use a small tip size, it's like using a light spraying of fairy dust, while the medium tip size gives you a heavier spraying of fairy dust. If you use the large tip size, it's more like splattering large drops of ink on your drawing or painting.

Dropper selects a color from the Sketchpad image. With the Dropper tool selected, click on the Sketchpad. The color under the Dropper tool becomes the active color for whatever you do next in the drawing. This is a handy way to perfectly match custom colors in your artwork.

Paint Bucket fills an area on the page with the color selected in the Colors drawer. If the color is poured within a closed shape, the interior of that shape is filled. If the

color is filled outside of a shape, the color fills the page except for any interiors.

If a gradation palette is on the surface of the Colors drawer, the **Paint Bucket** will fill with a color sweep. Rotate the page before performing a fill to change the direction of gradation.

CHANGING A TIP SIZE

Click on one of the five tip sizes to select the tip size for the tool you are using. The tip size defines the size of the lead in a pencil, the flow of ink in a pen, and the size of the ink drop in the ink bottle, and so on.

To change tip size on the fly, without opening the drawer, just press the **Tab** key. If you have the sound effects turned on, you'll hear a different tone for each tip size.

STENCILS

Stencils let you define areas to draw in or apply special effects to on your artwork.

Dabbler has four stencil tools, shown by the star icons in the Tools drawer:

 Stencil

 Freehand

 Float

 Polygonal

There are five tip size icons that determine the size of your stroke.

Dabbler comes with 300 pre-defined stencils you can select using the **Stencil** tool. Or, you can create your own stencil shapes using the **Freehand** and **Polygonal** stencil tools.

FILLING IN OR AROUND A STENCIL

Dabbler lets you draw inside or outside of a stencil; the stencil outline keeps the color from crossing the stenciled lines. Each stencil has two drawing modes:

- One lets you draw outside the stencil area — this mode is selected when green shows all around the stencil star

- The other mode lets you draw inside the stencil area — this mode is selected when green shows inside the stencil star

To switch between draw inside and draw outside, simply click on the icon. This toggles between the two options.

THE STENCIL TOOL

The Stencil tool comes with 10 extras in the Extras drawer.

Here's a bonus. If you click on the **Library** button, you can access any of the 300 pre-defined stencils stored in the Dabbler stencil libraries, including animals, astrology symbols, people, mechanical images, etc. Test out the **Library** button. When you select a library, the new stencils are displayed in the **Extras** drawer.

Using The Stencil Tools

To use a stencil:

Using the Stencil.

1. Click on the **Stencil** tool icon (show icon).

2. Set the stencil mode (draw inside or draw outside).

3. Choose the stencil image you want (from the **Extras** drawer or from the Library).

4. Place the cursor where you want the stencil to be drawn.

5. Holding down the mouse button, drag the stencil across the page. To make sure the image is properly proportioned, hold down the **Shift** key as you drag the stencil across the page. When you release the mouse button, the image will be perfectly proportioned. This goes for geometric figures as well as animals, people, etc.

Holding down the **Shift** key while using a stencil constrains its proportions.

6. Select the color and drawing tool you want to use with the stencil and draw inside or outside of the stencil (as dictated by your selected stencil mode).

7. To finish the stencil image, choose **Deselect** from the Edit menu.

Once you deselect a stencil, the stencil becomes part of the background image.

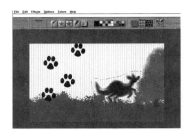

Using the Freehand stencil.

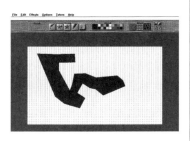

Using the Polygon stencil.

THE FREEHAND STENCIL TOOL

Use the **Freehand** stencil to draw irregular shapes by hand. Click and drag your mouse or stylus in the shape you want your stencil to take. Release your mouse button when your shape is completed.

This is a good tool to use when you want to select an object or a portion of your artwork for copying, cutting, or moving.

You can color or paint your freehand stencil as you would other stencils.

THE POLYGONAL STENCIL TOOL

The **Polygonal** stencil lets you draw freehand geometric stencils. To use the **Polygonal** stencil tool:

1. Click the cursor at the point where you want one side of the polygon to begin.

2. Move the cursor to create one side and click at the end of the side.

3. Move the cursor again to create the next side and so on until all but one side has been drawn.

4. Draw the last side, ending at the starting point.

THE FLOAT STENCIL TOOL

The **Float** stencil tool lets you draw a stencil shape and move the stencil and the underlying image to another location on your artwork..

Drawing inside a stencil.

Drawing outside a stencil.

To float an object, first outline it using the **Freehand Stencil.** Then select the **Float** tool and click in the stencil.

Once the pear has been floated, you can move it by clicking on it and dragging it to a new place.

The easiest way to copy a floating stencil is to hold down the **Option** key, click on the floating stencil, and drag a copy to a new location.

Once you deselect a stencil or a floating stencil, the stencil merges with the background image. A stencil is deselected when you click on another part of the image.

Using the Float stencil.

The **Float** tool can be used to great effect as you cut out stenciled shapes from colored backgrounds, or place stencils over existing art, and so on.

To use the **Float** stencil:

1. Select a stencil shape and place the stencil on the Sketchpad page.

2. Choose the **Float** stencil icon.

3. Place the cursor inside the selected stencil.

4. Hold the mouse button while you drag a copy of the stencil to another place on the page.

You can also cut, copy, and paste a stencil by selecting it with the **Float** tool and choosing **Copy** from the Edit menu. To paste it in an image, select **Paste** from the Edit menu and click on the page or location where you want the image pasted.

ADDING TEXT TO YOUR ARTWORK

A picture is worth a thousand words, they say, but once in a while a word can add powerful impact to art.

Dabbler lets you add text to your artwork using any TrueType font installed on your system.

SELECTING TEXT STYLE AND SIZE

You can select the type font, style, size, and color.

To select a typeface:

1 Choose the **Text** tool icon from the **Tools** drawer.

2 Choose **Text Styles** from the Options menu. Dabbler displays the Text Styles selection box.

The name of the first available type style is shown in the Style box at the top of the window. A sample of the type style is shown in the sample box. The font size is selected using the size bar slider at the bottom of the window. The preview window shows you the type style and size that is currently selected.

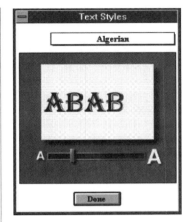

The Text Styles dialog box.

To select a different type style:

1 Click in the Style box. Dabbler displays a list of the currently available fonts.

2 Choose the font style you prefer.

3 To change the font size, move the size selection slider to the left (for smaller font size) or to the right (for larger font size).

4 When you have completed your selection, click **Done**.

To select a color for your text open the **Color** drawer and choose a color for the text, or select a color from the **Colors** drawer face.

Selecting a text font.

PLACING TEXT IN YOUR ARTWORK

To place text in your artwork:

1 Open the **Tools** drawer again and select the **Text** tool icon.

Adding text to an image.

Zooming in on an image.

2 Click in your image where you want to place your text.

3 Begin typing. Text is inserted using the currently selected color and type style. You can type one line at a time. If you want to type additional lines, reposition the cursor, click, and type the next line. (Dabbler doesn't do word warp.)

UTILITY TOOLS

Dabbler comes with three Utility tools: the **Magnifier**, **Grabber**, and **Rotate** tools.

MAGNIFIER

The Magnifier tool lets you zoom in and out on the Sketchpad.

To zoom in:

1 Select the **Magnifier** tool icon from the **Tools** drawer.

2 Click on the area on the Sketchpad where you want to zoom in. Dabbler zooms in a factor of 100% each time you click the mouse button.

Once you have examined your artwork in detail, you can resume viewing from a distance.

To immediately zoom out to 100% view:

1 Choose **Zoom Factor** from the Options menu.

Select **100%**. The drawing is immediately displayed at 100% of size.

To zoom out in 100% increments:

Choose the **Magnifier** tool icon from the **Tools** drawer.

Hold the **Shift** key and click on the Sketchpad page. The page is zoomed out by a factor of 100%.

MOVING THE SKETCHPAD PAGE

After you have zoomed in and out on your artwork, you might find that you need to readjust the page location on the desktop.

To move the page on the desktop:

Choose the **Grabber** tool icon from the Tools drawer. The screen cursor changes to a hand cursor.

Click anywhere on the page to grab the page.

To re-center the page on the desktop, click once on the image and release the mouse button.

To move the page elsewhere on the desktop, click on the image and hold the mouse button while you move the page around the desktop. Release the mouse when the page is where you want it.

ROTATING THE SKETCHPAD PAGE

Most artists seem to prefer to turn their Sketchpads slightly from the straight up-and-down orientation on the desktop, to match the natural drawing angle of their hand. Dabbler understands this and so gives you the Rotate Page tool to let you rotate the Sketchpad pages to suit your drawing style.

To rotate a page:

1. Select the **Rotate** tool icon in the **Tools** drawer.

2. Click on the page. You'll see a square that represents the page, and an arrow that shows you the angle of the paper.

3. While still holding down the mouse button, drag the arrow in the direction you want to turn your paper. The arrow and square turn as you drag. Hold the **Shift** key to prevent the page from rotating more than 90°.

4. Release the mouse button when your paper is turned to the angle you desire.

It will take Dabbler a few seconds to redraw the page in the new orientation.

To return the Sketchpad to the upright position select the Rotate tool icon and click once on the page.

To turn the paper without selecting the Rotate tool:

1. Press the **Ctrl** key (Windows) or the **Option** key (Mac) and drag the page to the angle you want it.

2. Click on the page. The square and arrow show over the page.

3 Rotate the page just like you would with the **Rotate** tool selected. If you also hold down the **Shift** key, the page turns in 90-degree increments.

PRACTICE SESSION

Now you know all about the Dabbler tools. Ready to try them out? This practice session gives you hands-on experience with several of the Dabbler tools. And at the end, you'll have a nifty drawing of a horse's head to show for your efforts.

1 Open the **Tools** drawer and select the **Pen** tool, then select the medium tip size icon. Open the **Extras** drawer and select the **Scratchboard Pen**. This extra gives you a smoother line than the **Ballpoint Pen**. Give yourself plenty of room to work by closing all of your drawers after you have made your selections.

2 Using your mouse or stylus, begin a simple drawing of a horse's head. This example was created using a pressure-sensitive stylus. Your results may be a little different if you are using a mouse, but you should still be able to end up with the same basic drawing.

Step 2.

3 Open the **Tools** drawer and select the **Marker** tool and the medium tip size. Close the drawer after you have made your selection.

Step 4.

Give your horse a mane and forelock. Remember, if you make a mistake at any point in your drawing, you can use the **Eraser** tool to erase all or part of the drawing and start over. You can also undo your last stroke by selecting **Undo** from the Edit menu.

Select the **Water Drop** tool, the smaller tip size icon, and the **Regular Water** extra. Close all of your drawers.

Use the **Water Drop** tool to smooth the horse's mane and forelock. Be sure not to use this tool too much, however, or your horse's mane may get muddied up.

For the finishing touch, select the **Spray Paint** tool and the smallest tip size icon and use it to add some highlights to the horse's face, neck, and mane.

Step 6.

Step 7.

CREATING A CANVAS

INTRODUCTION

Did you ever take a sheet of paper, lay it over a quarter, and rub a pencil across the paper? Remember the great effect when the texture of the quarter came through and you could see Washington's head on your paper?

IN THIS CHAPTER

 The Papers drawer

Textured strokes

Applying surface texture

Tracing paper

Practice session

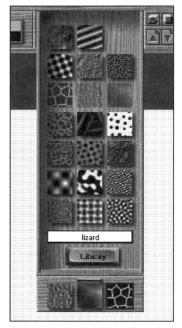

The Papers drawer.

Dabbler lets you play with textures just like that. Dabbler doesn't have any quarters, but it does have over 100 other textures you can use.

This chapter explains many different ways to use the textures in Dabbler's Paper drawer. It also talks about using tracing paper. At the end of the chapter, you get a chance to try your hand with textures during the practice session.

THE PAPERS DRAWER

The Papers drawer contains the paper texture icons you'll be using. Open the drawer and you'll see that it contains icons, like the Tools drawer, except these icons show you the texture effect you'll get when you draw on the paper.

Select a paper texture by clicking on the texture icon, just like you selected an icon from the Tools drawer.

Under the texture icons, the name of the currently selected texture is shown in the Texture Name box. The drawer face shows the last three textures selected.

Not only does Dabbler give you more textures than you'd probably find in any paper or art supply store, but there are also more unusual textures than you'd find anywhere else. In the figure showing the Paper drawer, the selected texture is "Lizard". Bet you don't find that in most paper stores!

The Papers drawer also has a **Library** button. You use this button to access the over 100 paper textures Dabbler stores in various libraries.

To select a new paper library:

Opening a paper grain file.

1. Click the **Library** button. Dabbler displays the Open Paper Grain File dialog box.

2. Select a new library from the File Name list and click **OK**.

3. The new library of textures is shown in the Papers drawer.

4. Choose a texture icon.

TEXTURED STROKES

When you draw by hand on regular textured paper, your paper shows texture before you draw, and then as you draw over it using a pencil or some chalk, the texture shows even more through your strokes.

With Dabbler, the paper texture doesn't show until you draw over it.

Chalk, left, is one of the tools that lets paper texture show through, while the **Marker**, right, does not.

With regular textured paper, you are limited to the texture of the sheet on which you are drawing; you cannot get more than one texture per page. But, with Dabbler, you can use as many textures per page as you wish, on one sheet of paper.

When you draw on regular textured paper, you'll notice that pencils and chalk really let the texture show through, while fountain pens and markers hide the texture. In Dabbler, several tools let paper texture show through their strokes:

 2B Pencil

Color Pencil

Brush

 Crayon

 Ballpoint Pen

 Chalk

 Frosty Water

 Grainy Water

Here's how to use one of these tools with textured paper:

1 Open the Papers drawer and click on the paper texture icon you want to use.

2 Open the Tools drawer and select one of the tools listed above.

3 Use your mouse or stylus to draw textured strokes.

4 You can change paper texture or drawing tool at any time.

Try out a few to get a good feel for how they all work.

APPLYING SURFACE TEXTURE

You can also apply a paper texture to an entire image or stenciled selection. The paper texture is applied over your existing drawing and textures, but lets them show through. Surface texture is applied as if a light source is casting a slight shadow on the paper.

Applying surface texture is easy to do. To apply a texture to an entire page:

1 Select the page you want to texturize.

2 Open the Papers drawer and select the icon for the texture you want to apply to your image.

*Use the Papers drawer to select a texture, then select the **Surface Texture** icon from the Tools drawer.*

The **2B Pencil** used with a
variety of paper textures.

The **Color Pencil** used with a
variety of paper textures.

The **Brush** used with a variety of paper textures.

The **Crayon** used with a variety of paper textures.

The **Ballpoint Pen** used with a variety of paper textures.

The **Chalk** used with a variety of paper textures.

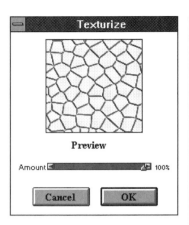

You can preview a texture before applying it to a page.

3. Choose **Texturize** from the Effects menu. Dabbler displays the Texturize dialog box.

The Preview window shows the effect of the surface texture if applied to your image.

4. Use the slider bar to set the amount of texture to apply.

5. Click **OK**. The texture is applied to the entire page. For most computers, this may take a few moments. Dabbler shows the texturize progress in a dialog box.

To apply surface texture to a specific area, stencil that area, then click inside or outside the area and apply the surface texture.

TRACING PAPER

Remember how much fun it was to create "great art" by tracing over someone else's picture? You could trace the outline and then fill in the image as your imagination dictated. You can still create great art using Dabbler's tracing paper.

To use the tracing paper:

1. Display the picture you want to trace. If this means importing a picture and pasting it in a Sketchpad, do that first. You can also import a photograph to trace.

Display an image you want to trace.

2. Add a blank page in front of the image you wish to trace.

3. Turn to the blank page.

Click on an image to apply a surface texture.

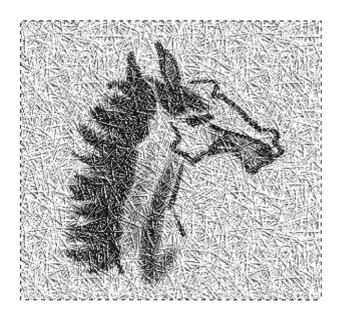

Click inside or outside a stencil to apply surface texture to a particular area.

99

Select the Tracing Paper icon.

4. Select the Tracing Paper icon from the icon group to the right of the Papers drawer.

The new blank page becomes see-through tracing paper, revealing the image beneath it.

5. From the Tools drawer, select the tool you want to use to trace the image.

6. To see what you've drawn without viewing the original art underneath, click on the Tracing Paper icon again to toggle it off. You can now see your drawing in all of its glory.

As you continue, you can paint, add effects, and simply make your drawing an original masterpiece.

PRACTICE SESSION

For this exercise, we'll be using a variety of drawing tools and papers to create texture and contrast in an image.

1. Select the **Scratchboard Pen** with a medium tip size and outline your friendly neighborhood FBI agent. Give him a tie, a Fedora hat, and a bland smirk.

2. Open the Papers drawer and select the **Lines** icon. Using the **2B Pencil** with a small tip, fill in his necktie with a conservative striped pattern, the **Pin Stripe** texture, right out of the Land's End catalog.

3. Use the **Crayon** with a medium tip size and the **Starry Sky** paper texture to color in his shirt.

Step 1.

Laying Tracing Paper over the image of the bears.

The traced bear.

4 To get a nice tweedy jacket, use the **Brush** tool with a small tip size and the **Medium Grain** paper texture.

5 A felt Fedora is too boring, so let's use the **Lizard** paper texture and the **Chalk** tool to spruce it up. Leave the hat band white for contrast.

6 Use the **Freehand Stencil** or **Polygon Stencil** tool to cut a stencil around the agent. Make sure the stencil is set to draw outside.

The **Freehand Stencil** draws smoother curves, but it can be pretty unmanageable for large, complex areas like this guy. You can do almost as well with the **Polygon Stencil** by using very small line segments. Try them both and see which one works best for you.

Use a variety of tools and paper textures to create an interesting background. You may want to include a shadow behind the man. The sample image uses the **Spray Paint** tool, heavily for the shadow, and lightly for the rest of the background. The textures are applied with the **Frosty Water** tool to get a more subtle effect.

Deselect the stencil, then use the **Regular Water Drop** tool with a small tip size to smooth the transition between the agent and his background.

Step 2.

Step 3.

Step 4.

Step 5.

Step 6.

Step 7.

USING COLOR

INTRODUCTION

Art created solely with black and white can be stark and dramatic. If you add shades of gray to the black and white, new possibilities exist for greater expression and subtlety. But to paint with all of the colors of nature . . . what splendor of expression is then conceivable!

IN THIS CHAPTER

- **The Colors drawer**
- **Color chip palettes**
- **Color gradation palettes**
- **Creating custom colors**
- **The Super Dropper tool**

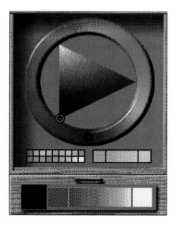

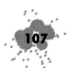

This chapter discusses Dabbler's rich coloring abilities and tells you how to make the most of them. Read on and open the door to Oz.

THE COLORS DRAWER

The Dabbler Colors drawer holds all the tools for using color in your artwork. In the Colors drawer, you will find the Color Wheel, Color Palettes, and the Cloning icon.

Use the Color Wheel to select a custom color, one of an infinite range of the color spectrum.

Color Palettes are either Color Chip or Color Gradation. Color Chip Palettes paint with a solid color, Color Gradation Palettes paint with graded shades of color.

The Cloning icon is used to create new art from existing art. Cloning is discussed in Chapter 10, Special Effects.

Click on the handle of the Colors drawer to open the drawer. Inside you see the Color Wheel and Cloning icon on the first row.

The next rows have the Color Chips Palettes on the left and the Color Gradation Palettes on the right.

COLOR CHIP PALETTES

Color Chip Palettes let you choose a color for use with any of the drawing or paint tools.

To select a Color Chip Palette:

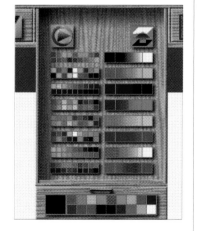

The Colors drawer

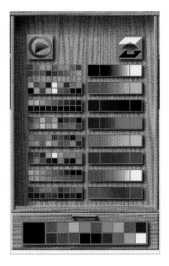 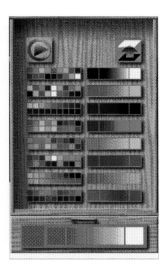

Left: The selected palette is shown on the face of the Colors drawer.

Right: The current color isdisplayed in the large color chip on the left of the palette. You can now close the drawer and paint or draw with this gradated color.

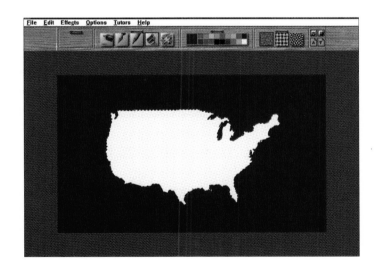

This figure shows the result of using the Paint Bucket tool with the blue color selected.

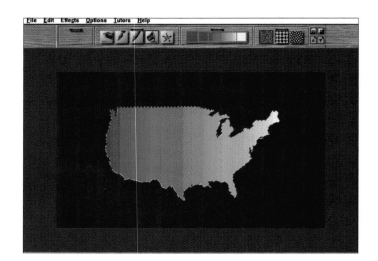

This is the result of using the
Paint Bucket tool with a color
gradation palette selected.

Use the outer circle on the
color ring to select hue and
the inner triangle to select
saturation and luminosity.

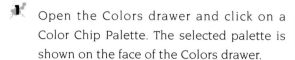

1 Open the Colors drawer and click on a Color Chip Palette. The selected palette is shown on the face of the Colors drawer.

The current color is displayed in the large color chip on the left of the palette. You can now close the Colors drawer and use any Dabbler tool to paint or draw with this selected color.

2 To change the selected color, click any of the color chips on the palette. The new color will be displayed in the large chip.

Changing the color selection will not change any colors already used on your work. To change any color on the work, you must re-do the stroke or activity using the new color.

COLOR GRADATION PALETTES

The Color Gradation Palettes show the gradations available for a selected color. If you select a Color Gradation Palette and then paint or draw, the color fill will reflect this gradation.

To select a Color Gradation Palette:

1 Open the Colors drawer and click on a Color Gradation Palette. The palette will be shown on the face of the Colors drawer.

The current color is displayed in the large color chip on the left of the palette. You can now close the Colors drawer and use any Dabbler tool to paint or draw with this gradated color.

A color gradation from blue to yellow.

When the Color Gradation Palette is selected, the Paint Bucket tool will fill an area with a graduated sweep of color. The Fill command will not create a color sweep — you must use the Paint Bucket tool for that.

2 To change the selected color, click anywhere on the color spectrum on the palette. The color grading will start from that color and continue to the right. The new start color shows in the large color chip.

Changing the Color Gradation Palette will not change any colors already used on your work To change any color on the work, you must re-do the stroke or activity using the new color selection.

CREATING CUSTOM COLORS

If you aren't satified with the default colors selected for you in Dabbler, feel free to create your own custom colors using the Color Wheel.

Every color in Dabbler is made up of a combination of each of the three primary colors — red, green, and blue. This is true even when working with black-and-white. For instance, white is made by mixing together equal parts of red, green, and blue. It's true! Black, on the other hand, is created by an absence of red, green, and blue. Also true!

You can create custom colors for your drawings by varying the amounts of red, green, and blue (or RGB components) present in each color by using the Dabbler Color Wheel.

You can change colors at any time. Changing colors while you are working does not affect your drawing in any way other than to provide you with more color options.

THE COLOR WHEEL

Before you customize a color, you should know a bit about the elements of color: hue, saturation, and luminosity.

- Hue is the position of a color along the color spectrum. For example, purple has a different position on the color spectrum than does yellow. What this means in color creation is, if you have selected purple as your color to customize and you move the Color Wheel indicator closer to the yellow hue, the purple color will approach the yellow hue.

- Saturation is the purity of a color's hue, moving from gray to the pure color. For example, a very dark blue may have mostly black with only a small amount of blue, and thus would have a very low saturation (color is closer to gray than blue).

- Luminosity is the brightness of a color on a scale from black to white. For example, light blue has a higher luminosity than a darker blue or dark red, but may have about the same luminosity as a light pink.

To create a custom color:

1 Select the color you want to modify. You can do this by double-clicking on a color in a Color Chip Palette or by clicking the Color Wheel in the Colors drawer. Dabbler displays the Color Wheel.

2 To change the color, move the small circle on the color ring to choose the hue.

3 To select the saturation and luminosity of the color, move the marker on the triangle.

The changes you select will be reflected in the large color chip on the Color Chip Palette.

Once you have created the color you wish to use, you can click on a Color Gradation Palette to create the gradation spectrum for that new color. Then use the Gradation Color Palette as described above.

THE SUPER DROPPER TOOL

Let's say you created The Mother of All Colors. A color so pure in your mind that it rates above all others. You use that color in your art, then somehow, as you continue with your work, you find that somehow you overrode the color in a Color Chip Palette. Oh, no! How will you ever recreate it! It's lost for all time. Desolation.

Not so! Remember Dabbler's nifty little Dropper tool? This seemingly innocuous little tool can save you.

To capture a color from your canvas:

1. Select the Dropper tool from the Tools drawer.

2. Once the Dropper tool is selected, place the tip of the Dropper directly over the color you wish to capture.

3. Click the mouse button. You'll see that the color you "sucked up" in the Dropper tool is now displayed in the large color chip on the Color Palette displayed on the Colors drawer. That is now your active color. You recaptured it!

4. Select a Color Chip Palette (any one) and the active color will now be a chip on that palette. Use it to your heart's content.

Now that you know how to use the Dabbler Color tools, take some time to experiment with them. Try out the Color Chip Palettes, to fill with solid color. Then see what creations are possible using the Color Gradation Palette. When you are ready, create your own Custom Color Palette. And finally, experiment with the Dropper tool. This might be a very important tool when you least expect it!

SPECIAL EFFECTS

INTRODUCTION

Dabbling with Dabbler's special effects filters can make your day . . . make it shine, make it storm, make it snow . . . whatever the effect you desire. These effects are cool. They can take a good image and make it spectacular.

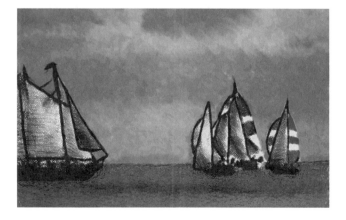

IN THIS CHAPTER

Special effects can also take a good image and make it not-so-good, so be careful not to overuse them. Just exercise a little self-restraint and you'll get incredible results.

This chapter discusses each of Dabbler's special effects filters and gives examples of how to use them. We also discuss the process of cloning a picture, a neat way to create new art from existing art. At the end of the chapter, you'll get a chance to try your hand at creating special effects during the Practice Session.

THE SPECIAL EFFECTS MENU

<u>R</u>edo	Ctrl+Z
<u>C</u>ut	Ctrl+X
Copy	Ctrl+C
Paste	Ctrl+V
C<u>l</u>ear	
<u>A</u>dd Page	Ctrl+N
<u>D</u>elete Pages...	
<u>B</u>rowse Pages...	
<u>G</u>o to Page...	
Selec<u>t</u> All	Ctrl+A
D<u>e</u>select	Ctrl+D
Reselect	Ctrl+R
Set Pre<u>f</u>erences...	

The Special Effects menu.

The Dabbler special effects filters are located in the Effects menu. Notice, if you don't have any Photoshop plug-in filters, that option is "grayed out" and unavailable for use.

These effects can be used alone or in combination, to add zest and interest to your artwork.

To choose an effect, double-click on the filter name in the menu. Let's start out by explaining each effect. The Texturize option is discussed in Chapter 8, Creating A Canvas.

FILL

The Fill command works like the Paint Bucket tool found in the Tools drawer. The Fill command will fill an entire image or a stencil with the current color.

Be careful! If a stenciled area is not selected when you choose this command, Dabbler will fill the entire image with the current color. Of course, if this happens, you can just choose **Undo** from the Edit menu and reverse the command.

Unlike the Paint Bucket, which fills an area along gradation lines, Fill pays no attention to gradation and simply fills with a solid color.

Paint Bucket fills along gradation lines.

Fill covers gradation lines with solid color.

AUTO CLONE

If you want to take a picture and color it to look like a painting or drawing, the Auto Clone effect filter is a handy tool. The Auto Clone filter applies random matching color dabs from the currently selected paint or draw tool to create a hand-drawn rendering of a photograph or other picture.

You can clone a picture by hand using the Clone tool in the Colors drawer (this is discussed later in this chapter), but with Auto Clone, Dabbler also gives you the option of sitting back and letting the program do it for you. Considering that cloning can take some time, this isn't a bad option. Kick back, sip a soda, think about your next piece of genius

*Using **Auto Clone** in a stenciled area with the **2B Pencil**.*

The size of the color dab used to create the cloned picture is determined by the tool and the tool tip size. A fine-point pen will make tiny dabs, whereas a large tipped piece of chalk will make larger dabs. Obviously, the amount of time it takes to clone a picture is dependent on what tool and tip size you select.

To Auto Clone a picture:

1 Select the picture you wish to clone.

2 Choose the **Clone** tool from the Colors drawer. The drawer will close when you

A Paint Bucket fill along gradation lines.

A Fill with no gradation lines.

select the Clone tool and the Clone tool icon is displayed on the drawer face.

3 Chose **Auto Clone** from the Effects menu. Dabbler will begin the process of cloning the picture.

Although Dabbler is doing all of the work, you are still in control. When you decide enough of the effect has been applied, you can stop Dabbler.

4 To stop the Auto Clone process at any time, click the mouse button.

FADE

The Fade effect filter decreases the intensity of the last special effect applied to an image, reducing the effect by 50%. Fading reduces the grainy reflection of many effects. You can use the Fade filter repeatedly to achieve softer, more subtle filter effects on your work.

To use the Fade filter:

1 Apply an effect to an image.

2 Immediately select **Fade** from the Effects menu.

3 Click on the area where you wish to Fade the effect. Dabbler will fade the image or the selected area.

GLASS DISTORTION

The Glass Distortion filter makes an image or stenciled area appear as though you are viewing it through glass.

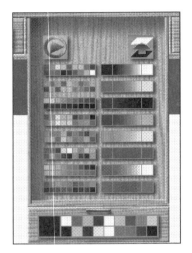

The open Colors drawer.

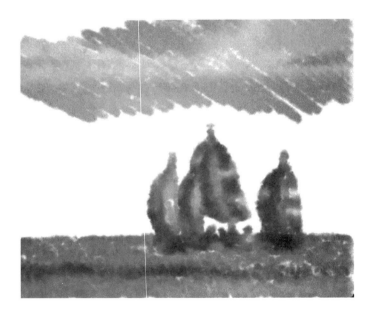

Cloning with the **Chalk** tool.

Stopping the **Auto Clone** process early.

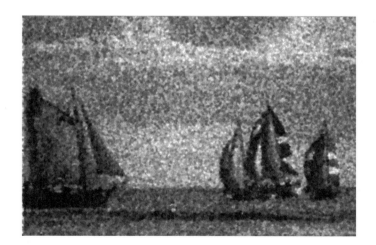

Letting the **Auto Clone** process continue to a more complete stage.

Even better, this effect reacts to the currently selected paper texture. For example, if you select the **Line** texture, this filter makes it look as if the glass is textured with lines.

If you select the **Basketball** texture, the glass overlay looks dimpled, almost like an orange skin.

The Glass Distortion effect can be applied to an entire image or to a specific area using stencils.

To use the Glass Distortion filter:

1. Select the image on which to apply the filter. If you want to distort a specific area, use the Freehand stencil to outline the area.

2. Choose the stencil mode, for distortion inside or outside of the stenciled area.

3. Choose the Paper Texture you want to use with the Glass Distortion filter.

4. Choose **Glass Distortion** from the Effects menu. Dabbler displays the Glass Distortion dialog box, showing the effect of the current level of distortion in the Preview window.

5. Choose the level of distortion you want using the sliding guide.

6. Click **OK**. Dabbler applies the distortion filter to the selected image or area.

The Glass Distortion dialog box.

Applying the **Fade** *filter over the* **Glass Distortion** *effect (left).*

Applying the **Fade** *filter over the* **Motion Blur** *effect (left).*

Using the **Glass Distortion** filter with the **Lines** paper texture.

Using the **Glass Distortion** filter with the **Surface** paper texture.

MOTION BLUR

The Motion Blur filter gives you the illusion of movement on an image by making the image look like you captured it in motion.

To use the Motion Blur filter:

1 Select the image on which to apply the filter. If you want to blur a specific area, use the Freehand stencil to outline the area.

2 Choose the stencil mode, for distortion inside or outside of the stenciled area.

3 Choose **Motion Blur** from the Effects menu. Dabbler displays the Motion Blur dialog box, showing the effect of the current level of blur on the selected area.

4 Using the sliding glides, set the radius and angle of the blur.

5 When you have the effect you want, click **OK**. Dabbler immediately blurs the image or specified area.

The Motion Blur dialog box.

NEGATIVE

The Negative effect filter inverts the colors in an image or a specific area.

When you select this filter, all colors are changed to their exact opposite, or complementary color. For example, black changes to white and blue changes to yellow.

Using the **Glass Distortion** filter with the **Lizard** paper texture.

Using the **Glass Distortion** filter with the **Halftone** paper texture.

*Applying **Motion Blur** to a stenciled area.*

*Applying the **Negative** filter to a stenciled area.*

To use the Negative filter:

1. Select the image on which to apply the filter. If you want to soften a specific area, use the Freehand stencil to outline the area.

2. Choose the stencil mode, for distortion inside or outside of the stenciled area.

3. Choose **Negative** from the Effects menu. Dabbler immediately inverts the image or specified area colors.

SOFTEN

The Soften filter has the same effect as putting a soft-focus filter on a photographic lens. It decreases the clarity and sharpness of an image in a soft, subtle way, sort of like the focus in an old Doris Day movie.

You can apply the Soften filter repeatedly for a more exaggerated effect. If you go one step too far, just use the Undo command in the Edit menu to remove the last effect.

To use the Soften filter:

1. Select the image on which to apply the filter. If you want to soften a specific area, use the Freehand stencil to outline the area.

2. Choose the stencil mode, for distortion inside or outside of the stenciled area.

3. Choose **Soften** from the Effects menu. Dabbler immediately softens the image or specified area.

SHARPEN

The Sharpen filter has the opposite effect of the Soften filter. It increases the clarity of an image.

You can apply this filter repeatedly for a heightened effect, but be careful, your results can be pretty outrageous if you oversharpen.

To use the Sharpen filter:

1. Select the image on which to apply the filter. If you want to sharpen a specific area, use the Freehand stencil to outline the area.

2. Choose the stencil mode, for distortion inside or outside of the stenciled area.

3. Choose **Sharpen** from the Effects menu. Dabbler immediately sharpens the image or specified area.

CLONING AN IMAGE

As far as cloning goes, it's the next best invention to two-wheeled unicycles. It's really neat. It might just be the best tool Dabbler has to offer.

Cloning is a way of copying an image using different tools. And it's super simple to do.

Just open up a picture or photo to clone. (See Chapter 5, Sketchpads, for how to open and import pictures into Dabbler.) Then, get started.

The **Sharpen** filter has some undesirable results when applied too many times.

Applying the **Fade** filter over the **Surface Texture** effect (left).

Softening a stenciled area.

Sharpening a stenciled area.

Here's all you do:

1. Choose the picture or image you want to clone.

2. Make sure a blank page is inserted just before the image you want to clone. Turn to the blank page in front of the picture to be cloned.

3. Select the **Clone** icon from the Colors drawer.

4. Choose a painting or drawing tool from the Tools drawer. The tip size determines how big the dabs of color are on the cloned picture. You can use chalk, paint brush, pencil, or whatever tool you want, with whatever tip size or Extra you wish.

5. If you want to texture a portion of the image, select the texture and draw a freehand stencil around the area to have that texture.

6. Begin painting or coloring. An image of the underlying picture will begin taking shape on the blank page.

7. If you want to see the underlying picture while you work, click the **Tracing Paper** icon at the top right of the screen. Unclick the Tracing Paper icon if you just want to see the page on which you are drawing.

You can get some great effects by changing drawing and paint tools or by applying effects filters to the cloned drawing.

Selecting the Clone icon from the Colors drawer.

133

*Cloning with the **Brush** tool.*

*Cloning with the **Brush** tool while the original image is visible on the tracing layer.*

If you don't want to do the cloning yourself, and would like someone else to do it for you, Dabbler is happy to oblige. Set up for cloning as you did here and then choose Auto Clone from the Effects menu. (See the Auto Clone section above for more detail.)

PRACTICE SESSION

For this exercise, choose an image you already have, or get one from the CD ROM that accompanies this book. This example uses a photograph of boats, but you can use any image that interests you.

1. Place a blank page before the image, choose the **Clone** icon from the Colors drawer. Select the **Tracing Paper** icon so you can see the clone as you work with it.

2. Use the **Chalk** tool to lay in the background. Use the larger tip size for broad areas, and the small and medium size for edges and small areas. In this image, the **Chalk** covers the sky and the sea. When this is done, click the **Tracing Paper** icon again so you can see the painting without the underlying image.

3. Use the **2B Pencil** with a small tip size to fill in your subject. You can use any paper texture you like. This painting uses **Medium Grain**. You can keep **Tracing Paper** enabled while you work, but turn it off when you are through with the **Pencil**.

Step 2.

Step 3.

4. Using the **Grainy Water Drop** tool with the small tip size, smooth out the penciled areas.

5. Use the **Marker** tool to define outlines and shadows. Turn off the clone by selecting a color palette from the Colors drawer.

6. Choose a special effects filter that suits your painting. For this image, we applied the **Glass Distortion** filter after texturizing the surface.

7. The **Glass Distortion** effect turned out a bit strong, so we used the **Fade** tool on it once.

The final painting.

Try your hand at adding different effects to the sky or water. Be daring. Experiment. If you take an enormously false step, use **Undo** to recover. Have fun. Make art!

Step 4.

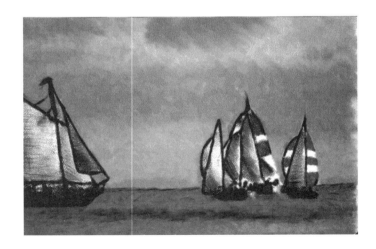

Step 5.

Step 6.

Step 7.

RECORDING A SESSION

INTRODUCTION

Have you ever looked at a piece of art and wondered how the artist created it? For instance, did DaVinci really draw a melon for Mona Lisa's head to start, and then fill in the features? It's a question we'll never answer because DaVinci didn't record his creative session for posterity. Had he had Dabbler, those with inquiring minds might have the answer to one of life's greatest puzzles.

IN THIS CHAPTER

 Recording a session

 Playing a session

 Annotating a session

 Practice session

Next, wet brush paint the background to blend the colors.

But, not to worry. You do have Dabbler, and thus can record your creative sessions for generations to come. Or you can play back sessions that have been created by someone else, including those that come with this book and learn by watching. Section Two of this book is chock-full of sessions for your edification. Play back the sessions and learn from the masters.

When you play back a session, it's like watching a movie of the original artist at work. As you record your sessions, you can also add text annotation to describe what is happening. You can annotate what tool you are choosing, how you'll use it, and even which muse is speaking to you!

Read this chapter to learn how to record a session, how to annotate a session, how to play back a session, and all about the session playback controls. Follow the Practice Session to record your own session.

RECORDING A SESSION

You can record a session of you creating art work from scratch, or of you creating art from an imported picture.

- If you are creating work from scratch, open the Sketchpad or Flipbook to the page on which you will create your work before you begin your session.

- If you plan to transform an imported picture, import the image to your Sketchpad or Flipbook before you begin your session.

To record a session:

1. Open the Sketchpad or Flipbook where you will create the work.. Import the image to the canvas if you will be altering an image.

2. Select Sessions from the Options menu. Dabbler displays the Sessions dialog box. If other sessions already exist, they are shown in the preview window at the top of the dialog box.

3. Click the red Record button. The Stop and Record buttons move to the face of the Tools drawer during recording.

4. Begin creating your picture. Dabbler will record all activity on the Sketchpad or Flipbook.

5. When you have finished your picture, or wish to stop the session, click the square Stop button. Dabbler displays the Save Session dialog box.

6. Enter the name of the session and click OK. The session is saved in the current session library. To save to a different library, you must first create the new library.

To create a new library:

1. Choose Sessions from the Options menu.

2. Click the Library button.

3. Type the name of the new library in the Library box and click OK.

The Sessions dialog box.

The Stop button (left) and the Record button (right).

The Save Session dialog box.

 Open that library before creating your new session and when you save the session it will be saved to that new library.

PLAYING A SESSION

Sessions are saved in libraries. You can have several sessions in one library.

To play a previously recorded session:

Select a session from the scrolling preview window.

1 Open a Sketchpad or Flipbook to an empty page.

2 Select Sessions from the Options menu. Dabbler displays the Sessions dialog box.

The scrolling window displays the sessions in the current library and the session names (such as candle or pear).

3 Select a session from the scrolling window, or click the Library button to load a new session library.

4 If you click the Library button, choose the sessions library and click OK. Then from that library, choose the session you want.

5 When you have selected the session you want to play, click the Play button. Dabbler begins playing the session, creating the artwork on the empty canvas currently displayed.

SESSION CONTROLS

When a session begins to play, the Session Control buttons are displayed on the face of the Tools drawer.

These buttons control how the session is played back:

Click the Pause button to pause a session.

Click the Play button to resume playback of a session.

Click the Step button to step through the session one stroke at a time.

Click the Stop button to stop the session.

The Session Control buttons are displayed on the face of the Tools drawer when you play back a session.

ANNOTATING A SESSION

When you playback a session, fascinating as it is, you might feel frustrated if you cannot tell exactly what it is the artist is doing. What tools is the artist using, what size tip, all the other questions you might have.

This is where annotating the session comes in handy. Dabbler lets you add text to your recorded sessions, so you can note step by step what you are doing. This text is then displayed at the bottom of the screen when the session is played back.

To add text annotation to your session:

1. Select Annotate Session from the Options menu while a session is being recorded. Dabbler displays the annotation dialog box.

2. Enter the text to be displayed, up to 256 characters.

3 Click **OK** and continue to record the session.

4 After you have finished the session, save it as described above. Then play back the session. When the session is played back, the session playback is paused and the text is displayed in a text window at the bottom of the screen.

Annotated text is displayed on the bottom of the Dabbler window when you play a session.

PRACTICE SESSION

If any of this sounds confusing, don't worry. It's really quite easy. Here, have a quick go at it.

1 Open a Sketchpad to an empty page, or add an empty page to an existing Sketchpad. Choose the tool you want to use.

2 Select Sessions from the Options dialog box. Dabbler displays the current session library in the dialog box. Press the red Record button. The Stop and Record buttons are now transferred to the front of the Tools drawer.

You are now ready to begin. Select Annotate Session from the Options menu. In the dialog box, type "Create the background for your picture." Click OK to return to the Sketchpad page and resume recording.

3 Color in the background of your picture. Use several paint or drawing tools and a variety of colors and textures. Be creative. Enjoy yourself.

When you have finished the background, select Annotate Session again from the Options menu. In the dialog box, type "Now outline your picture." Click OK to return to the Sketchpad page and resume recording.

4 You get the idea. Finish your picture, taking time to annotate your steps. You can enter text describing the composition elements, lighting and shadows, color combination, textures, anything that you think might help someone to recreate your art.

When you have finished, press the black square Stop button.

Enter the name of your session in the dialog box and click OK. Your session has been saved.

5 Now, open the Sketchpad to a blank page or add a page to the Sketchpad.

Select Sessions from the Options menu.

6 Find your session in the current library, highlight it by clicking on the session thumbnail picture. When the session is highlighted, a black box appears around it.

7 Press the triangular Play button. You will see your session played back in living color, complete with each annotation.

These sessions cannot be edited, so give careful consideration to what you want to annotate before you begin your recording session.

Nifty and easy, wasn't it?

OUTPUTTING YOUR ART

INTRODUCTION

Creating art is most of the fun of Dabbler. But has there been an artist born who doesn't want someone to view the final art?

Dabbler understands this desire and, so, gives you several ways to output your art for viewing. This chapter discusses printing Sketchpads and Flipbooks, and exporting Flipbooks as movie files.

IN THIS CHAPTER

- **Printing a Sketchpad**
- **Exporting a Flipbook**
- **Printing a Flipbook**

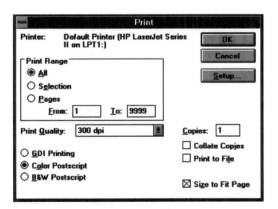

149

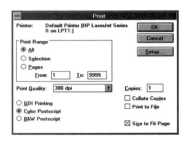

Dabbler's Print dialog box.

PRINTING A SKETCHPAD

To print a Sketchbook, you must first select the Sketchbook to print or to print from. Then:

1. Select Print from the File menu. Dabbler displays the Print dialog box.

2. Select the print range. All prints all pages in the Sketchpad. Selection prints the current page. Pages lets you indicate which pages to print.

3. Select the desired print quality. The maximum resolution depends on your printer capabilities.

4. Indicate the number of Copies to be printed. If you are printing numerous quantities of several pages, select Collate Copies to have the printer print sets of pages in sequence.

5. Select Print to File if you want to print at a later time.

6. To have your printed page fill a sheet of paper, check the Size to Fit Page option.

7. Choose the print style:

 GDI Printing: choose this option if your printer is not a PostScript printer.

 Color PostScript: choose this option for color PostScript printing.

 Black and White PostScript: choose this option for black and white PostScript printing.

If the default printer selected is not the printer you want to use, press the Setup button. Dabbler displays the Print Setup dialog box.

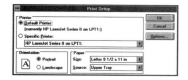

> 🖌 Select the printer you want to use. Scroll down the list of available printers to find the one you need.

The Print Setup dialog box.

> 🖌 If you need to change the Orientation, click on the Portrait or Landscape option.

> 🖌 If necessary, change the Paper Size and Paper Source.

If you want to check further print options, press the Options button. Dabbler displays the print Options dialog box.

> 🖌 Dithering. Isn't it nice to know that you can choose whether or not to dither. Most of us do it when we least appreciate it. Ah, but wait. This dithering has to do with how colors are created. Dithered color is a color produced by a pattern of differently colored dots that simulate the desired color. This is different from a solid color. Now do you know more than you did? Anyway, if you choose to dither, you can choose to use coarse or fine dots, or line art.

The Print Options dialog box.

> 🖌 You can also control the Intensity of the printing, sliding between darker and lighter, depending on your printer and the effect you desire.

3. Finally, you can choose to print True Type (fonts) as Graphics.

4. When you have made your selections, click OK. Click OK again to close the print Setup dialog box.

5. You are now ready to print. Click OK in the Print dialog box to begin the printing.

PRINTING FLIPBOOKS

Printing Flipbooks is a bit different than printing Sketchpads, since you will likely be printing Flipbooks on card stock. Dabbler lets you choose the size and binding dimensions of the hand-held Flipbook you will print.

To print a Flipbook:

1. Choose Flipbook Setup from the File menu.

2. Fill in the setup values you want:

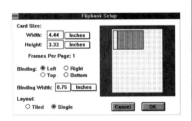

Flipbook setup options.

- CardSize is the printed size of the Flipbook. Units can be in inches or centimeters. The default size is a fairly standard, reliable card size to use.

- The Frames Per Page limit is set by the Layout selection at the bottom of the dialog box.

- If you choose Tiled, Dabbler will print multiple frames on a single sheet of paper. The Frames Per Page will indicate the maximum number of frames that can be printed on a page.

If you choose Single, only one frame will be printed per page.

Binding controls where the Flipbooks will be stapled, either at the Left, Right, Top, or Bottom. You decide.

Binding Width sets the amount of white space for the binding. You don't want the binding to be too small or some of the frame image might get lost in the binding.

3 After setting the Flipbook Setup options, select Print from the File menu

Page numbers will be printed in the binding area to help with assembly.

EXPORTING FLIPBOOKS

You can export your Flipbooks as QuickTime or Video For Windows (.avi) files.

To export a Flipbook:

1 Select Export from the File menu to save your animation as a digital movie. Dabbler displays the Revert Frame dialog box.

2 Name the Flipbook and choose the drive and directory where you want to save it.

3 Click OK.

Use the Revert Frame dialog box to export Flipbooks.

COLOR PLATES

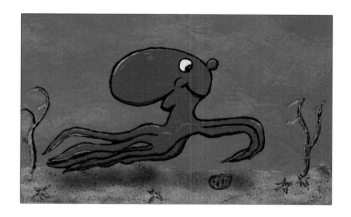

Chapter 14: Creating a Flipbook

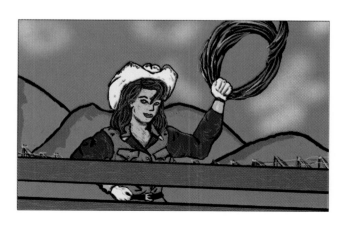

Chapter 15: Creating a Coloring Book.

Chapter 15: Creating a Coloring Book.

Chapter 15: Creating a Coloring Book.

Chapter 15: Creating a Coloring Book.

Chapter 15: Creating a Coloring Book.

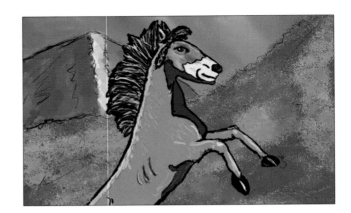

Chapter 15: Creating a Coloring
Book.

Chapter 15: Creating a Coloring
Book.

Chapter 16: Creating a Calendar

Chapter 16: Creating a Calendar

Chapter 16: Creating a Calendar

Chapter 16: Creating a Calendar

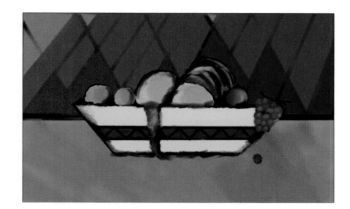

Chapter 20: Creating a Still Life

Chapter 21: Creating a Landscape

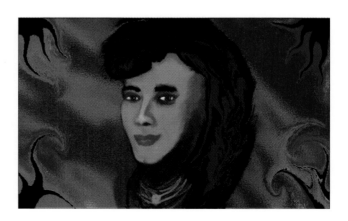

Chapter 22: Creating a Portrait

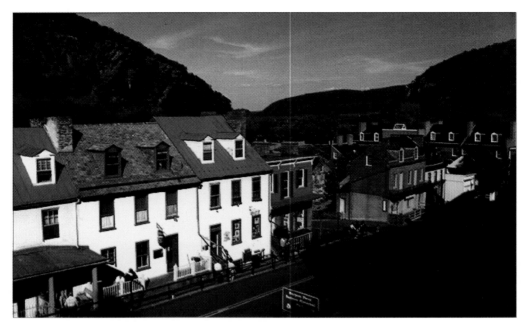

Chapter 23: Turning Photos into Artwork (*before*)

Chapter 23: Turning Photos into Artwork (*after*)

ART TUTORS

INTRODUCTION

If you're new to the art design world and have never had an art lesson in your life, it's still easy to learn to draw. Because, with your purchase of Dabbler, you also got your own personal art tutor! Yes, it's true. You'll find your tutor taped to the inside of the CD-ROM case. Remove the tutor, add water, and ask for a lesson.

IN THIS CHAPTER

 Tutorials

 Tutoring sessions

 Tutorial navigation

Actually, come to think of it, that was the old version. In Dabbler 2, the tutor is actually packaged in the CD-ROM.

You doubt? Read on to find out how to start your personal art lessons with your own personal CD-ROM tutor.

TUTORIALS

Before you begin your tutored lessons, you should know the basics about Dabbler. If you haven't read Section One of this book, please do so. It provides all of the information you need for using Dabbler. If you have a quick question about the program, you can use the Dabbler on-line tutorials to get an answer. These tutorials include:

Lesson 1: *Dabbler Basics* teaches you about the Dabbler screen, drawers, sketchpads, colors, textures, and extras. Pretty much what is discussed in Section One of this book.

Lesson 2: *Using Stencils* teaches you about the Dabbler stencils and extras and how to use them. Similar to our discussion in Chapter 7, The Tools Drawer.

Lesson 3: *Tracing Paper & Cloning* teaches you about how to use tracing paper and how to clone, as we did in Chapter 8, Selecting Your Canvas, and Chapter 10, Special Effects.

Lesson 4: *Flipbook Animation* gives you all the information you need to create a Flipbook, much as our Chapter 6, Flipbooks, did.

TUTORING SESSIONS

Once you know the basics of using Dabbler, you are ready for your art tutor. It's time to conjure up your tutor and start your lesson.

To conjure a tutor:

Select the appropriate art lesson from the Tutors menu:

 Cartoon Animation teaches you how to draw animated cartoons. This session is narrated and is fairly in depth.

You can select from several different lessons once the tutorial session begins.

 Drawing Cartoons teaches you how to draw cartoon figures. This tutor is by Bruce Blitz, who has several How To Draw Cartoon books in bookstores and art stores everywhere. This tutor session is narrated and flows quickly.

You can select from several different lessons once the tutorial session begins.

These tutorials will take you step by step through each lesson. A few of the lessons have practice tips included. You can stop the tutorial at any time and practice what you have just been taught. When a lesson ends, you can review the lesson, moving the slider back to the left, or you can choose another lesson.

The Drawing Cartoons tutorial teaches you how to draw cartoon figures.

You can review tutorial sessions again and again.

The Cartoon Animation
tutor.

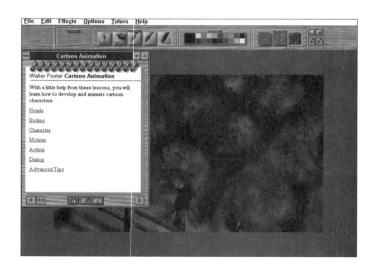

Selecting a lesson.

To pause a tutorial while it is playing:

1 Click on the Pause button at the far right end of the slider. Dabbler will pause the lesson at its current point of discussion.

2 To restart the lesson, click on the Pause button again. The lesson resumes without interruption.

To stop a tutorial while it is playing, click on the black square Stop button on the sliding bar of the tutorial window. The lesson will stop and, in the Animation lesson, a curtain will drop. In the Cartoon lesson, the window will simply go blank. The slider returns to the beginning of the lesson.

To resume the lesson, click on the Pause button at the right of the slider. This starts the lesson again at the beginning.

TUTORIAL NAVIGATION

There are a few quick navigation ideas you should know just to make life easier when you use a tutor.

To move one page forward or one page back, use the Next Page/Previous Page buttons.

The Home button takes you to the beginning of the Tutor.

The Return (double triangles) button takes you back to the topic you just read.

If you want to practice what the tutor tells you but the tutor is in the way of your Sketchpad, simply click and drag the title

Click on the Pause button to temporarily stop a lesson.

Beginning a lesson.

Tutor buttons, from left to right: Previous Page, Return, Home, Index, Bookmark, Next Page.

bar to where you want the tutor to be. You don't even have to be polite about it.

- If you want to close a Tutor window, click the window close box.

- Even CD-ROM tutors can get long-winded, so if you want to speed things up a bit, you can move the slider on the Tutor window and take the express bus to the end of the line.

- To change topics in the selection window, click on the green underlined text. This jumps you to the new topic.

- In the introductory text for each tutorial, you might see some words in green with a dotted underline. These are hints, and they usually tell you where to find a tool or define a word.

- The Index icon brings up an alphabetical listing of all the subjects covered in the tutor. Use the index to look up specific commands by name.

BOOKMARKS

Bookmarks are a handy Dabbler feature that allow you to mark a location in a tutor session and quickly jump to that spot upon demand. You'd probably use bookmarks for sections you are currently practicing and where you need to continually refer to the lesson. Or, they're handy if you want to continue a lesson after a break.

The Set Bookmark icon creates a new bookmark. To set a bookmark, click the Set Bookmark icon. Dabbler displays the Bookmark Define dialog box. Fill in the bookmark name and click OK.

Use this dialog box to name a Bookmark.

The Goto Bookmark icon jumps to a specified bookmark location. To jump to a bookmark, click the Goto Bookmark icon. Dabbler displays the Bookmark dialog box. Select the bookmark you want, click OK, and Dabbler jumps to that location.

Now that you know how to use a Tutor, try a few lessons on your own. Good luck!

This dialog box brings you to a specific Bookmark.

CREATING A FLIPBOOK

INTRODUCTION

This session shows you how to create a Flipbook to animate a cartoon sequence.

Our flipbook shows an octopus swimming underwater. It's fairly simple. We want to show you how to draw each frame to achieve the illusion of

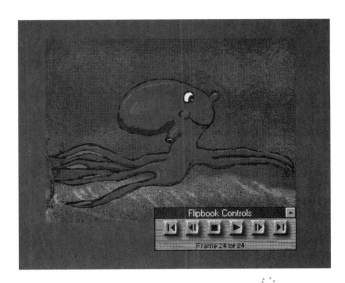

Frame 24 of 24

IN THIS CHAPTER

- **Before you begin**
- **Session notes**

BEFORE YOU BEGIN

To run the session, you need to open the Flipbook file provided on the sample disk. The name of the file is **octopus.fbk**.

Open the pad. Dabbler displays the first frame of the Flipbook. You can see from the control panel information that there are 24 frames in this Flipbook.

motion, so we had to keep it simple. But, once you start creating your own, you can go into as much detail as your heart desires.

Just a note here. This chapter is fairly advanced as far as using the Dabbler tools. If you are new to paint programs, you might want to skip this chapter and work through some other chapters to get some experience on using the drawing tools and creating pictures. When you are comfortable using the tools and familiar with the ways Dabbler can help with your art, you can return to this chapter.

SESSION NOTES

Take the time now to run the Flipbook. You can change the speed of the animation by changing the speed bar on the expanded control panel.

It is difficult to discuss Flipbook creation frame-by-frame detail, so what we'll do is provide notes in the sequence in which we created the Flipbook, providing illustrations as appropriate. It might help you to have the Flipbook open as you read these notes, so you can run the Flipbook and understand what we're saying as far as animation and continuity between frames.

To start, we **Filled** the first frame with the blue of the ocean and **Spray Painted** in some white and used the **Liquid Brush** to get a wavy effect in the water.

Then, to finish the water, we used the **Soften** and **Glass Distortion** effect filters.

We used the **Chalk** and the **Ink Bottle** to add the ocean floor. That finished the first frame.

We then followed the exact process in the remaining 23 frames until we had a moving ocean floor and rippling water.

Next came the starfish and plants. We added the starfish and plants to a frame in the middle. We wanted these traveling throughout the Flipbook and it's easier to introduce them a couple at a time from the beginning, rather than having them all appear at once.

Starting in the middle made it easier to track each element of the edges of the animation.

Once we created the starfish and plants, we selected each piece one by one using the **Freehand** selection tool and pasted them into sequential frames using the **Tracing Paper** feature to keep track of the placement.

This is sort of tricky to do. For one thing, if you're not careful, you'll find yourself animating a character or element in the wrong direction. Because the starfish and plants are almost sedentary compared to the octopus, in the grand scheme of things, these objects should move *backwards*. Try to figure that out and juggle knives at the same time! In one of our first attempts, one starfish actually raced the octopus. It's sort of like learning how to comb your hair while looking into a mirror. Once you get the hang of it, it's a breeze.

To start, we **Filled** the first frame with the blue of the ocean and **Spray Painted** in some white and used the **Liquid Brush** to get a wavy effect in the water.

Then, to finish the water, we used the **Soften** and **Glass Distortion** effect filters.

Once we created the starfish and plants, we selected each piece one by one using the **Freehand** selection tool and pasted them into sequential frames using the **Tracing Paper** feature to keep track of the placement.

Then came the octopus (Joe). Adding Joe was tough because up to this point all of the animation was either extremely generic and lacking in precise detail (you know, you've seen one sea cactus, you've seen them all) or relatively simple and cloned and placed for animation. Joe was a different story.

Each tentacle had to move with each frame. And we wanted the spineless trait of the octopus to be evident by having his body sort of "flow" through the water, not really maintaining a constant strict form. To accomplish this spinelessness, we had to draw Joe from scratch in each frame, as opposed to copying his head and adding the tentacles.

Pop Quiz: What is the single physical factor that limits the space which an octopus can squeeze into or through?

Answer: His *eyeball*! Yep, the size of the octopus's eye is what limits him from squeezing into the smallest crevice or under the lowest rock.

Okay, back to Joe. We used the Tracing Paper to keep up with what Joe was doing in the last frame to guide us in creating his movements in each current frame.

We could have kept Joe in the center of the frame for the entire animation, but we wanted some forward and backward movement to simulate speed, sort of a burst forward at the end of each "stroke." We also give Joe some up and down motion, for more life-like movement.

Then came the octopus (Joe). Adding Joe was tough because up to this point all of the animation was either extremely generic and lacking in precise detail (you know, you've seen one sea cactus, you've seen them all) or relatively simple and cloned and placed for animation. Joe was a different story.

It was fairly simple to achieve these motions. We just moved each frame a little forward or a little in the desired direction of each upwards or downwards motion.

It was fairly simple to achieve these motions. We just moved each frame a little forward or a little in the desired direction of each upwards or downwards motion. To give it a bit of randomness, we ad-libbed these motions, rather than strictly orchestrating them. The only restriction was to make sure Joe didn't jump from the bottom of the picture to the top of the picture in a single frame. Had that happened, we would have had to draw starfish circling around his head.

One recommendation we can make for all animation is to have a point that you keep constant throughout the frames. For Joe, the center of the frame was our point, off which we based all motion. No matter how far forward or backward we drew Joe, we always made sure to come back to the center point the keep the "flow" of the piece going.

That's it. That's how Amazing Joe was created. Now that you've read the notes, run the session again and see how these notes apply to the creation of the animation.

You've seen how we created our flipbook; go try one on your own. If you have not yet read *Chapter 6, Flipbooks*, you should go back and read it now. That chapter explains the technical stuff you need to know before you start creating your flipbook.

A FEW WORDS OF WISDOM

Before you go, a few words of wisdom on creating Flipbook animation.

The most important thing to remember about animation is that, just like with still art, it is an illusion.

There really is no motion or depth. While this might be confusing at first, you will soon begin to realize that this illusion is the *power* of animation. Since it is an illusion, you, the animator, become a magician of sorts with complete control over the worlds you create.

An animation does not have to be perfect and extremely detailed to be successful. Much of what you see in good animation is not really that complex, but complexity is hinted at or implied with small changes in color or additions of minor details and our brains fill in the gaps. That's where the power of suggestion comes into play. Learn to use these "implications" of detail to give your animations real-world motion.

That's it for the soapbox. Go, ye, and render unto Dabbler that which is yours.

One recommendation we can make for all animation is to have a point that you keep constant throughout the frames. For Joe, the center of the frame was our point, off which we based all motion. No matter how far forward or backward we drew Joe, we always made sure to come back to the center point the keep the "flow" of the piece going.

CREATING A COLORING BOOK

INTRODUCTION

In this session, we'll show you how to create a coloring book, and then how to use that coloring book over and over again.

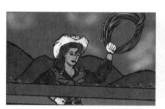
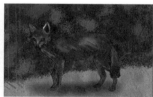

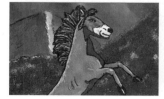

IN THIS CHAPTER

- **Before you begin**
- **Session notes**

BEFORE YOU BEGIN

The coloring book has been saved as a Sketchpad. To open the Sketchpad for this session:

1. Select **Open** from the File menu.

2. Find and open the 10_chapter.pad in the directory of files included with this book.

This Sketchpad is the coloring book. The first page of the coloring book will show an outline drawing.

Once you color the page, it can look like this.

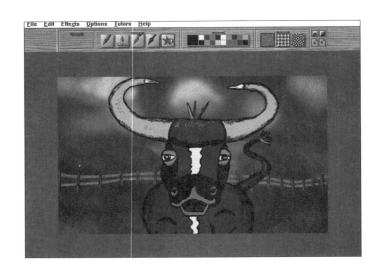

To create a coloring book, you must first create a new Sketchpad for your art.

Once you have created and named the coloring book Sketchpad, you can begin to create line drawings of your art. We have included seven drawings to start off your coloring book.

Boot Hill. The outline of the boot is fairly simple. There is some detail in the boot itself, but as you color it in, you can color over the detail and then redraw it or paint carefully, preserving the detail.

What, no amplifier? In this drawing, the details of the guitar are fairly complicated. You do not need to put all of that detail in your drawings; detail can be added after you color in the general form.

Neat fire, isn't it? We're awfully proud of it. Notice the detail in the logs. Again, you don't have to put that much detail in your line drawing.

Your basic cowgirl. Doesn't look like much yet, but wait and see what you can do when you color this picture right.

Shouldn't trust this horse within a hoof's length. Look at that eye! But, with careful coloring, this horse can become a Beauty.

Lean times for coyotes, looks like. Vegetation is scarce, too, but when you color this, you can create this as a garden or jungle if you want.

SESSION NOTES

To use the coloring books, you can:

- Paint directly on the drawing

- Add a blank page in front of the drawing and turn on the Tracing Paper, using the original art as a guideline.

- Select and copy the entire image onto a blank page

Let's take a quick look at how you can use these sketches in the coloring book to work up some attractive art. We'll assume you are using the Tracing Paper and blank page option here.

Let's start with the bull.

That a lotta bull! He looks docile, but don't trust that "come hither" look. That is, unless you color him cartoony and render him harmless.

First, color in the background.

Using the Pen, the Water Drop, and the Spray Paint, fill in definition, shadows, and clouds.

Fill in the foreground colors and color the fence, using Chalk, Pens, and Markers if you want.

Using the Pen, copy the outline of the bull onto your page.

Remember, use your imagination. Also, don't forget the lesson you learned when coloring as a child. OUTLINE! Outline your primary focus in black for greater definition.

Now let's do the cowgirl.

First, create the sky and clouds by completely coloring the page in blue and using the Spray Paint to add clouds.

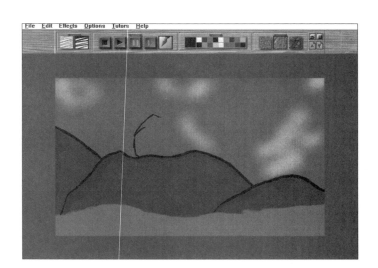

Next, draw in the middle scenery and using a combination of tools (Chalk, Pens, Markers, etc.) color in the scenery.

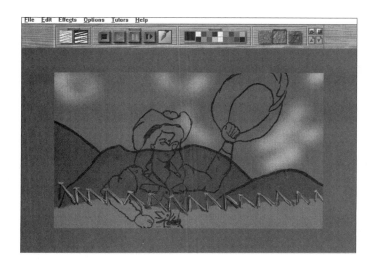

Copy the outline of the cowgirl onto your picture and continue coloring in the picture background.

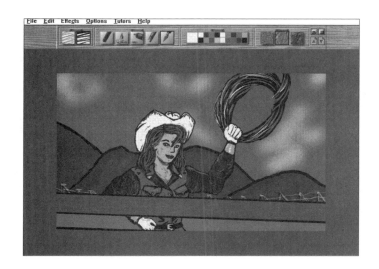

Here's one way the cowgirl can look at the end. Hmm, this sample shows that it ain't the years that affect yer, it's the miles

What western theme would be complete without a guitar?

The thing to note here is that with Dabbler, unlike with real paints, you can paint a background, draw an outline of the subject (guitar, here) and then paint the subject, without any color distortion from the previously painted background.

The Old West smoked with gunpowder and campfires, much like the one you can color now.

For greatest effect here, start with a black background, then add a touch of orange glow to the ground before drawing your logs.

Use Chalk and the Spray Paint to color in the general flame area.

Now, using the Liquid Brush, sweep the fire into living flames. Spray Paint a fine mist of blue for an aura of smoke. S'mores, anyone?

Cowboy boots are much more colorful now than they were in the old days. Only a dandy or a really good gunfighter had colored boots back then.

Once again, start with the background, then color the boot, and finally add the details that make the boot look lived-in. The way to make this picture interesting is to have fun with the background. Color it, texturize it, soften it, give it a touch of motion blur, experiment. You might find an effect you really enjoy.

Now to Old Paint. We've got to give this critter some life, and a gentler personality.

Because you will always have the outline of the horse available, you can change the background to suit the mood you want to convey. Here Old Paint is frolicking in a mountain meadow. For a different mood, you could have him rearing up in a corral, or attacking a guitar (everyone's a critic).

Once you have the outline, you can color Old Paint any way you want. Make him a paint, or a roan, or even an appaloosa! It's your choice. Just be gentle around the eyes. Good highlighting in the eyes can save this horse.

For our last subject, the ubiquitous coyote. Mr. Blue of the Moon, on the prowl.

Again, vary the background on this guy to change the tone of the picture. He looks pretty satisfied here. But how different he would look with a desert background, with only a few scabby cactus around. And, as with the horse, the eye highlights can dictate how the viewer will feel about the animal. Is he hunted, ravenous, sly, or looking for a cuddle? The eyes are the mirror to the soul with animals. Play with shadows, highlighting, and expression.

Have fun.

CREATING A CALENDAR

INTRODUCTION

There are many things you can do with the art you create using Dabbler.

This session will show you how to begin to design your own calendar. We'll show you January through April. You can then continue through to December.

BEFORE YOU BEGIN

Before you begin running the session, you must have your Sketchpad set up properly.

1. Open a new Sketchpad and name it calendar.pad.

2. Select the Cotton Paper texture for the entire canvas.

The pictures we included for this session are:

- January: a sled
- February: a valentine
- March: high-top sneakers
- April: an umbrella

For the rest of the year, you might use these suggestions:

- May: flowers in a field
- June: kites flying
- July: a turtle in a pond
- August: a beach scene
- September: school supplies or autumn leaves
- October: a pumpkin patch or scarecrow
- November: Pilgrims or a harvest
- December: a snow person

As you can see from our samples, it isn't necessary to make the calendar art super detailed and intricate. Of course, you can if you wish, but simplicity works well for calendar art. You get the gist of the month without getting lost in detail. With no distraction, you can focus on the individual days. Oooo, that's deep. Quote us, if you'd like.

For January, we will create a sled. We start with the sled outline, using the Pen (size 1, smallest, with Ballpoint extra).

Next, we use the Eraser (size 2, Full extra) to erase the crossover lines, using the Pen to redraw any lines that are affected.

Using the Chalk tool, we color in the sled, the runners, and the sides of the slats.

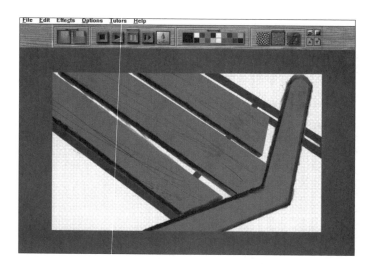

We again use the Pen to add detail to the sled, drawing in marled lines for wood grain and blending them into the wood with the Water Drop tool. We add definition using the Pen and tracing the edges of the sled boards, blending the lines with the Water Drop.

We use the Pen and light colors to add highlights to the sled and runners.

Once again using the Pen, we create the rivets in the boards and add the guide rope.

We blend the lines of the rope with the Water Drop and add the Text for the month name.

For February, we start out with Filling a black background, then use the Ink Bottle to add ink spots of color (size 3 drops).

The heart is easy. We just use the Heart Stencil, placing it in the middle of the image, using the Shift key to maintain proportion. Then, switching to Coarse Grain paper texture, we use the Paint Brush to splotch in a lacy border on the outside of the heart.

Using Fill, we color the inside of the heart red. Yes, it is conventional, but passionate.

Then, first using Chalk and Water Drop and then Spray Paint, we color highlights on the surface of the heart.

We use black Chalk to write in the words "I LOVE YOU", rewrite using blue for emphasis, and highlight it with white Chalk.

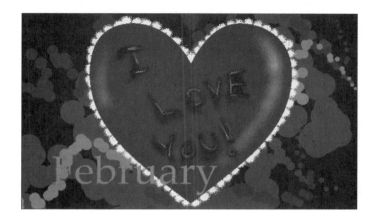

Finally, with the Text option we add the name of the month.

For March, a pair of sneakers seems appropriate. Running in the cold winds, your knuckles aching when the basketball slams into your fingers, trying to fly a kite on frantic gusts of wind. Yes, sneakers seem fitting to the month before spring.

First we use the Spray Paint and the Chalk to color in the background. Selecting a second color of chalk, we add dimension to the background with a few strokes, achieving a sort of sandlot color.

Then, using the Pen (size 1, smallest, with Ballpoint extra), we drew lines, creating a board. Continuing with the Pen, we added colored highlights to the floor, creating a wood effect.

Using the Pen, we draw the outline of the sneakers.

Still using the Pen, we color in the sneakers using several different colors.

Finally, we add details and highlights to the sneakers using the Pen and complete the picture by using Text to add the month name at the bottom.

For our last month, April, what else could it be but April showers, typified by the umbrella. Another option could have been the Eiffel Tower...April in Paris.

To begin, we color the background using the Fill command with the Gradation Palette selected. This gives us graduated color across the background.

Next, using the Pen, we draw the outline of the umbrella.

We use Chalk to color in the umbrella, blending the colors with the Water Drop tool.

Using the Pen and Water Drop, we color the handle of the umbrella.

To achieve the rain effect, we use the Ink Bottle tool and sprinkle the water onto the umbrella. Neat effect, don't you think?

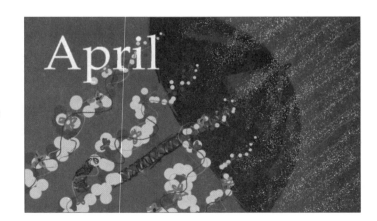

Finally, because April showers bring May flowers, we show the rain bouncing off the umbrella as a shower of flowers. We created the flowers by using the Ink Bottle and Pen and bright colors. Finally, we use the Text tool to add the name of the month.

Okay, now you've seen what we've done. It's time to try your own creation. Remember, let your imagination run wild. If our suggestions at the beginning of the chapter don't match your own thoughts of the months, forget our suggestions. Go for your own mental images of the months. Enjoy!

CREATING A LOGO

INTRODUCTION

In this session, we'll show you how easy it is to create a logo. This logo will be a simple design, just to illustrate the power of simplicity. Following the session, you can begin creating your own logos.

mike wordman

IN THIS CHAPTER

🐾 **Before you begin**

🐾 **Session notes**

BEFORE YOU BEGIN

Before you begin running the session, you must have your Sketchpad set up properly.

1. Open your session Sketchpad to a blank page.

2. Select the Cotton Paper texture for the entire canvas.

To begin, we use the Polygonal Stencil to outline a square area for the logo.

Next, using the Chalk (size 4, second largest) in five different colors, we create a simple background in the stenciled area.

Next, we choose the Algerian type style in a medium size and place the logo initials on the background.

Finally, we add the logo name as text under the stenciled area. And there it is, a simple, yet effective logo.

207

You can change the appearance of a logo by applying texture to the background at any point in the creation. Here we add the Spots surface texture to the background.

You can achieve some great special effects with logos, as well. Try a few, test yourself. Create a logo to place on the corner of each piece of art you create.

CREATING YOUR OWN SCREEN SAVER

INTRODUCTION

There are hundreds of screen savers on the market these days, with thousands of images. No longer are we constrained to have fish and toasters flying across our screens. And, better yet, you can now create your own screen saver with Dabbler.

This session shows how to create yet another fine piece of art, a mountain biker, that can then be exported to a screen saver program to customize your idleness.

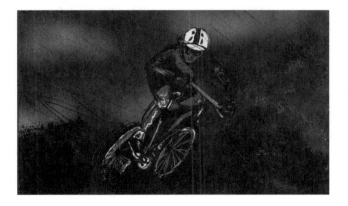

IN THIS CHAPTER

 Before you begin

 Session notes

 Exporting to a screen saver program

BEFORE YOU BEGIN

Before you begin running the session, you must have your Sketchpad set up properly.

 Open your session Sketchpad to a blank page.

 Select the Cotton Paper texture for the entire canvas.

First, we create the background using Chalk (size 5, largest) and 3 different colors.

Next, using the Water Drop tool, we blend the background, to remove distinct chalk lines. Then we add a touch of cloud to the background using the Paint Spray tool (size 5, largest).

Switching to the Fibers paper texture, we then use the Paint Brush to paint in the ground and hillside. Notice the bristly effect given to the paint strokes by the fibers texture.

Then we blend the ground colors using the Water Drop, leaving the edges of the colors untouched, preserving that wild grass appearance.

Once the ground is blended, we use the Water Drop to create the bike path and patches of grass to the side of the path.

Now, we sketch in the biker using the Pen (size 1, smallest, with the Scratchpad extra). There's no need to go into tremendous detail, since you will be painting over the sketch lines later. Notice the perspective and angle in the sketch. The rider leans into the hill, as he would in reality. Use the Dabbler tutor for more help on drawing perspective.

Using the Chalk, we fill in the bike colors. Afterwards, we use the Water Drop to blend the lines and colors.

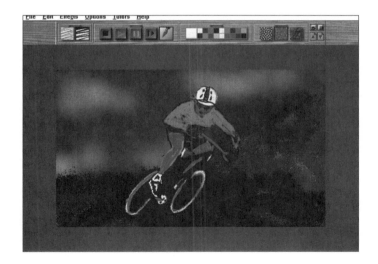

We color in the biker using Chalk.

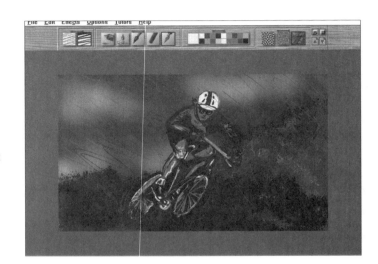

Using the Pen, we define the figure and features of the biker, to finish off the picture. Careful attention to detail can add dimension to the drawing. For example, notice the skinned right knee, the detail of the shoes, and the helmet detail. Nice little touches that round out the picture.

EXPORTING TO A SCREEN SAVER PROGRAM

You will have to consult the instructions for your screen saver progam to find out the appropriate file format you need to use. Most likely, it will be tiff files or bmp files.

To save your image in the correct format, select Save Page As from the File menu. Choose the file format from the pop-up list on the lower right of the dialog box, name your image, and click Save. You will also need to make sure your image is saved to the correct folder or directory, which is probably the one containing your screen saver program (again, see your screen saver manual for more details).

CREATING A POSTER

INTRODUCTION

In this session, we'll show you how to create a nifty dinosaur poster that will thrill any Lizard Loving Kin. As you study the session, watch how we use Paper Textures to add effect to the picture and how the use of text adds dramatic impact.

IN THIS CHAPTER

 Before you begin

 Session notes

BEFORE YOU BEGIN

Before you begin running the session, you must have your Sketchpad set up properly.

 Open your session Sketchpad to a blank page.

 Select the Cotton Paper texture for the entire canvas.

To start the picture, we use the Chalk tool (size 5, largest) to color in the background. Notice that the colors we select are bright and vibrant, to add impact to the poster. And because we planned the art ahead of time, you can see how we leave room at the left of the page for later art not requiring the same background.

Next, we use the Water Drop tool to blend the background into a solid wash.

We add the Soften effect to the background, to blend and soften the colors.

Next, using the Chalk tool, we color in the palm tree body.

Then, switching between the Marker, Water Drop, Pencil, Spray Paint, and Pen tools, we fill in the details of the tree fronds and bark. We finish off the details with the Water Drop to add shadow and dimension.

Next, using the Marker (size 1, smallest tip), we sketch in the dinosaurs.

Using Chalk, Water Drop, and Pen, we begin filling in the dinosaurs. Use your creative juices. We don't know for sure what any of these creatures looked like, so let your imagination "saur."

Check out the texture we select for the T-Rex head. We use the Polygonal Stencil to select the head, then select the Basketball texture before coloring with Chalk. Great effect, don't you think?

Once we finish the details of the dinos, we select the left panel area.

Using black Chalk, we color in the left panel.

Using green Chalk, we add a coat to the left panel, giving it a jungle effect.

Now for the fun part. We select the Lizard paper texture and apply it to the selected panel. Cool. Fits the dinosaur theme, don't you think?

Using different colors of Chalk, we draw in highlighting squiggles of color. Notice how the selection of neon colors makes the poster vibrate with energy.

We use the Text icon to add colored letters, and the poster is finished. You can print out the picture and hang it or, if you have a printer that will support printing on fusible fabric, you can even print the image and fuse it on a little tyke's t-shirt.

CREATING A STILL LIFE

INTRODUCTION

In this session, we'll show you how to create a still life. After studying the session, try creating your own still life, using anything you find around your house. Even the old masters used still life paintings and drawings to improve their skills. It gives a great opportunity to experiment with the concepts of composition, lighting, and color.

IN THIS CHAPTER

 Before you begin

 Session notes

BEFORE YOU BEGIN

Before you begin running the session, you must have your Sketchpad set up properly.

 Open your session Sketchpad to a blank page.

 Select the Cotton Paper texture for the entire canvas.

We use Chalk (size 5, largest) to color in the foreground of the tabletop.

With the Polygonal stencil, we select an area to Clear, thus creating the back of the table.

Next, we use the Pen (size 2, second smallest, Scratchboard extra) to hatch in the background.

Using three different colors, we color in the hatched background using the Pen tool (size 2, Scratchboard extra).

Now, we use the Water Drop tool (size 3) to blur the lines of the background.

We use the Spray Paint to draw texture lines on the tabletop and the Water Drop tool to blend the lines into the color.

With the Chalk (size 1, smallest), we fix a background line and then outline the still life image.

Next, we color in the bowl using Chalk (size 2).

229

Then, using the Pen (size 2, Scratchboard extra), we redraw the bowl lines and design, and using the Chalk we fill in color on the bowl design.

We use the Water Drop tool (size 2, Regular extra) to smooth and blend the lines in the design and provide shading and toning.

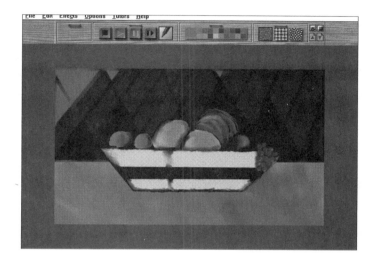

Alternating between Chalk and Marker, we color in the fruit, first placing basic color and then highlighting and defining.

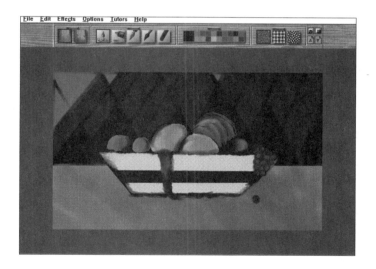

Finally, still using Chalk and Marker we add the stem and a fallen grape, touch up the whole image, and the still life is done.

Have a go at creating your own still life. Remember, push yourself and experiment. No one has to see your efforts, but with each effort you progress. Have fun.

CREATING A LANDSCAPE

INTRODUCTION

In this session, we'll show you how to create a land-scape. This particular landscape is an apple orchard, viewed from an unusual perspective, one that will challenge you to duplicate. You'll see the progression in creating this landscape, from background, to general definition, to layering of colors, through completed picture.

IN THIS CHAPTER

 Before you begin

 Session notes

BEFORE YOU BEGIN

Before you begin running the session, you must have your Sketchpad set up properly.

 Open your ses-sion Sketchpad to a blank page.

 Select the Cotton Paper texture for the entire canvas.

To begin, we create the background with the green and yellow Spray Paint (size 4, second biggest tip).

Then we blend the background using the Water Drop tool with various extras. Watch the Extras drawer during the playback to get an idea of how we use each extra.

Tree trunks are added along a grid using the Chalk tool (various sizes/colors), and we add natural highlighting and roots with the Liquid Brush tool (size 1, smallest).

Details are blended using the Water Drop tool and then we use the Spray Paint to start forming the tree canopies.

We add apples using the Spray Paint (size 2), alternating red and yellow colors.

Then we add the treetops, again using the Spray Paint for color and the Water Drop for blending (size 5, with Frosty extra).

We add shadows and high-
lights using the Spray Paint.

Next, we add the fence and
fill-in touches with the Chalk
and the Water Drop.

Lastly, we use the Pen to draw in the branches, to finish off the picture.

If you hadn't noticed, this is a difficult perspective to draw from. We hope you try it. Stretch yourself. You might amaze yourself.

CHAPTER **22**

CREATING A PORTRAIT

INTRODUCTION

In this session, we will show you how to create a portrait, starting with the background, then outlining the features, and finally taking the back-and-forth steps to complete the portrait with highlights and shading.

IN THIS CHAPTER

 Before you begin

 Session notes

BEFORE YOU BEGIN

Before you begin running the session, you must have your Sketchpad set up properly.

 1. Open your session Sketchpad to a blank page.

 2. Select the Cotton Paper texture for the entire canvas.

To begin, we use several colors of Chalk (size 5, largest tip) to draw in the background, varying the strokes and angles of the strokes.

We then apply the Soften filter twice. Each time the filter is applied, it softens the image. Softening twice gives a nice, smooth effect.

Next, we apply the Glass Distortion filter, at a medium setting. This gives a nice, unobtrusive background to the portrait.

We sketch the basic outline with the Pen tool (size 1, smallest, with the Ballpoint extra).

We then fill in the outline with the Chalk (size 5). After getting the basic color layer down, we blend the colors using the Water Drop tool (size 4, with the Grainy extra).

Details are added using the Pen tool (size 1, with Ballpoint extra).

From this point on, we alternate between the Chalk, Water Drop, and Pen tools to get the shading and highlighting right.

We add brown to the hair with the Chalk tool and use the Liquid Brush (size 3) to give the hair volume.

Final touch-ups are made using the Chalk and Water Drop tools, adding more shading and, finally, a necklace.

The final touch is using the Liquid Brush to add the decorative border.

It is impossible to document each and every stroke of this creative process, but if you run the session several times and study each stroke, you will learn a great deal about highlighting, shading, defining, and everything else involved in creating a portrait.

TURNING PHOTOS INTO ARTWORK

INTRODUCTION

In this session, you will work with the Cloning tool, turning a photograph into a work of original art.

You will start out with this picture of a small village. We'll call it Sleddville.

IN THIS CHAPTER

 Before you begin

 Session notes

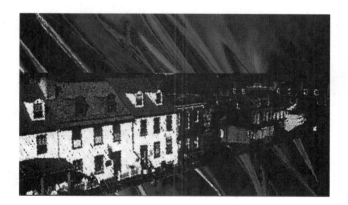

Sleddville.

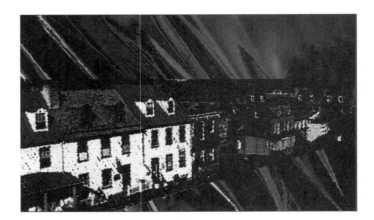

After the session, you will end up with a piece of work similar to this drawing of that Sleddville photo.

BEFORE YOU BEGIN

Before you begin the session, you must set up your Sketchpad properly. If you don't follow these steps exactly, the session will not progress properly.

To set up:

1. Open your sessions Sketchpad. Turn to a blank page.

2. Select Import Page from the File menu. From the Select Image dialog box, select the harper.rif file.

3. Click OK. The image is imported and placed on the blank page of your Sketchpad. Add a page in front of this page.

4. You should now see a blank page. Behind it should be the picture of Sleddville. Click the Clone icon to the upper right of the drawers. (Insert icon here) Now you are ready to run the session.

5. Select Sessions from the Options menu. Click the Library button.

6. Choose chptr_18.ssk from the Library menu. Click OK.

7. When the session shows in the Preview window, click the triangular Play button. The session will begin.

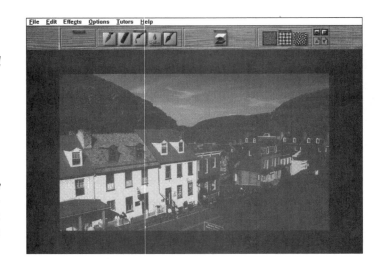

We used the Cloning feature all of the way through the session.

Here is what your Sketchpad should look like before you start the session.

This figure shows your blank page as tracing paper, to show the photo underneath the current blank page. You will not have the Tracing Paper option selected to start with.

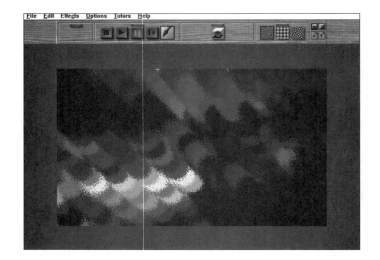

We start off with the Paint Brush (size 5, largest tip) to get the background colors "pulled through" to the blank page.

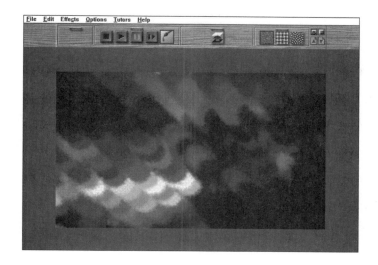

We then select the Soften effect from the Effects menu, to soften the texture of the background.

Next, we smear the background using the Liquid Brush (size 4, second largest) to get a marbled, velvety effect.

Now we use the Tracing Paper (click on the Tracing Paper icon) so we can see the rows of buildings to properly mask them. Using the Polygonal stencil tool with the Shift key to constrain the straight edges, we eyeball the angle and draw lines around the row of houses.

Then, using the Chalk tool (size 1, smallest), we color close, crosshatch lines to bring more details of the buildings into the picture.

To enhance the colors, which seem a little blah, we choose the Pen tool (size 1, with Ballpoint extra) and apply the AutoClone effect to beef up the tonality of the building.

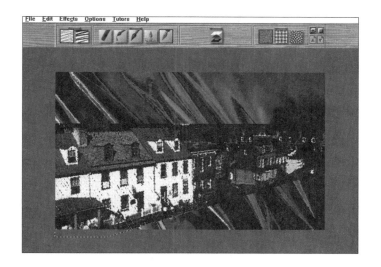

As a final step, we run the Sharpen filter (Effects menu) for greatest clarity.

Et voilá. A unique art masterpiece from a photograph.

INDEX